THE
STREETWISE
GUIDE TO
FREELANCE
DESIGN AND
ILLUSTRATION

Theo Stephan Williams

NORTH LIGHT BOOKS
CINCINNATI, OHIO

The Streetwise Guide to Freelance Design and Illustration. Copyright © 1998 by
Theo Stephan Williams. Manufactured in China. All rights reserved. No part of this book
may be reproduced in any form or by any electronic or mechanical means including
information storage and retrieval systems without permission in writing from the publisher,
except by a reviewer, who may quote brief passages in a review. Published by North
Light Books, an imprint of F&W Publications, Inc., 1507 Dana Avenue, Cincinnati,
Ohio 45207. (800) 289-0963. First edition.

Other fine North Light Books are available from your local bookstore, art supply store or
direct from the publisher.

02 01 00 99 98 5 4 3 2 1

Library of Congress Cataloging-in-Publication Data

Williams, Theo Stephan
 The streetwise guide to freelance design and illustration / by Theo Stephan Williams.
 p. cm.
 Includes index.
 ISBN 0-89134-801-8 (alk. paper)
 1. Commercial art—United States—Marketing. 2. Graphic arts—United States—
 Marketing. I. Title.
NC1001.6.W56 1998
741.6′068′8—dc21 97-29695
 CIP

Edited by Kate York
Production edited by Jennifer Lepore
Cover and interior designed by Chad Planner

The permissions on page 141 constitute an extension of this copyright page.

Dedication

For my mom, who gave me the freedom to experience lots of "streetwise" endeavors from the time I was very young. Thanks, Mom!

Acknowledgments

Thanks to North Light Books for letting me share my "street smarts"—I have wanted to write this book for a long time. Terri Boemker Lewis, my development editor, was most generous and patient with me as I juggled the overwhelming demands on my time—including a move across the country right in the middle of it all!

Joel, my loving husband, gives me so much opportunity to experience everything that comes my way—without *getting* in my way himself.

Thanks also to my close friends and business partners Chris Wire, John Bowling and Bev Shillito who have creatively allowed me to transcend the challenges of my career.

To my two sisters, Renee and Kathy, who I'm sure at times consider me an alien from another planet—their love and attention is a very important element in my professional and personal life.

I would also like to acknowledge the fact that I am blessed with many close friends around the country, who have enriched me with many street smart—and fun—moments!

About the Author

Photo by: Jack Holtel

In 1985 Theo Stephan Williams founded Real Art Design Group, Inc. in Dayton, Ohio, a full-service graphic design firm that has won more than two-hundred design awards from local as well as international associations. Real Art has also been recognized with Design Excellence awards from the American Advertising Federation every year since 1987, with nineteen winning entries in 1996. Theo was an adjunct visual communications faculty member at the University of Dayton from 1990 to 1995. In 1997 she moved to southern California to develop a West Coast office for her firm. Currently, Theo is maintaining the role of president for her firm as well as pursuing interests in writing, documentary photography and the fine art of domestication.

Table of Contents

6
INTRODUCTION

7
CHAPTER 1:
ARE YOU SUITED TO FREELANCING?

- Twelve Questions to Confirm Your Freelance Aptitude
- Organizational Skills
- Managing Yourself
- Adolfo Martinez-Perez: On Being a Freelancer
- Developing Self-Confidence
- The Rewards of Life as a Freelancer

24
CHAPTER 2:
HOW TO SET UP YOUR FREELANCE STUDIO

- Master the Environment
- When Working at Home Doesn't Work Anymore
- Choosing and Paying for Equipment
- Jan MacDougall: On Being a Freelancer

39
CHAPTER 3:
HOW TO FIND MARKETS FOR YOUR WORK

- How to Find Business
- Finding the Right Freelance Niche
- Planet Fez Productions: On Being a Freelancer
- Building Self-Confidence
- Following Through for Effectiveness
- Sheila Berigan: On Being a Freelancer
- The World Wide Web

56
CHAPTER 4:
HOW TO PROMOTE YOURSELF

- Creating the Right Identity System
- Know the Differences Within the Creative Industry
- Promoting Yourself for the Long Term
- The Importance of Selling
- Do You Need a Self-Promotion Piece?
- Josef Gast: On Being a Freelancer
- The Ultimate Priority—Your Portfolio
- Presenting Your Portfolio
- How Do You Know When You Need an Agent?

73
CHAPTER 5:
KEEPING YOUR SKILLS CURRENT

- Streetwise Design and Illustration Skills
- Keeping Your Skills Up-to-Date
- Communication Skills
- Franklin Hammond: On Being a Freelancer
- More Effective Communication Tools

86
CHAPTER 6:
HOW TO BE PROFESSIONALLY EFFECTIVE WITH CLIENTS

- The Key Is Flexibility
- Dealing With Politics
- Making a Commitment
- Learning to Say Yes and No
- John Ceballos: On Being a Freelancer
- Educating Your Client
- Being the Best
- Intuition—Your Strongest Ally
- Linda Souders: On Being a Freelancer

101
CHAPTER 7:
HOW TO MANAGE YOUR TIME

- Knowing Your Own Work Process
- Paperwork Know-How
- Planning Ahead
- So You Have Waited Until the Last Minute!
- Geoffrey Smith: On Being a Freelancer
- Taking Time Off

113
CHAPTER 8:
NEGOTIATING, PRICING AND BILLING

- Being a Winner at Negotiating
- The Win-Win Philosophy
- Comparing Apples to Apples
- Making the Client Feel Good
- Establishing Rates
- Curtis Parker: On Being a Freelancer
- Raising Your Rates
- Establishing Credit
- Billing—The Really Fun Part

130
CHAPTER 9:
THE LAW AND YOU

- The IRS Can Be Your Friend
- How to Protect Yourself and Your Art
- Copyright Law
- Mark Levy: On Knowing Your Rights
- Give Your Client Some Education
- Legal Issues That May Arise
- In Closing

141
PERMISSIONS AND PHOTO CREDITS

142
DIRECTORY OF CONTRIBUTORS

143
INDEX

Introduction

You know that person. Self-confident, savvy, always knows what to say and, more importantly, when to say it. That's a streetwise person! OK, I'll admit it. Lots of people are born streetwise—but most people aren't.

This book is for the independent freelance people in the giant industry of creativity—graphic design, advertising, illustration, photography and art direction of all varieties—who were not born street smart. This book identifies the ins and outs of freelance "smarts," while keeping in mind how hard you work and everything you have questions about.

Freelancing is not for everyone. If you're a freelancer, you are an independent thinker, you like the freedom of setting your own schedule and you don't mind not knowing when the checks will be in the mail! This book gives you the information to develop a comfort level with the million-and-one things a freelancer encounters. It will ask you questions about yourself, give you checklists, offer insight from professional freelancers and give specific advice on how to move forward with confidence and success into the streets of the freelance world!

6

Chapter 1

Are You Suited to Freelancing?

Do you *really* want to work on your own? Probably, or you wouldn't be reading this. But do you have what it takes to be successful as your own boss? Will your personality, natural preferences and current skills help or hurt you? The following questions are a quick way to find out.

Twelve Questions to Confirm Your Freelance Aptitude

1. Do you like making decisions on your own?
2. Do you like to set your own work schedules?
3. Can you stay focused on your work and meet deadlines?
4. Do you enjoy gathering input from others, then taking the information and developing creative concepts on your own?
5. Do you enjoy researching areas of knowledge you are unfamiliar with?
6. Do you like to sell?
7. Do you like to meet new people—often?
8. Do you enjoy updating your portfolio—and presenting it?
9. Do you find it easy to communicate effectively?
10. Are you comfortable discussing money?
11. Do you enjoy clerical work?
12. Do you like to take lump-sum checks to the bank?

If you answered yes to even half the questions above, you have the beginnings of what it takes to be street smart in the freelance business. The goal of this book is to get you to answer all (or at least most) of these questions not only affirmatively, but with clarity and a good amount of elaboration on each subject.

Don't worry if you look at a few of these items in horror or with disdain. Even if you absolutely despise, say, updating your portfolio or doing clerical work, you will learn the

importance of these tasks within the framework of being a freelancer, and may decide beforehand that you need to delegate them to others, or you might learn how to view these tasks in a different light.

Organizational Skills

Organization is crucial, but it's important to distinguish between the outward appearance of being organized and the nitty-gritty of true organization—the kind that will get you through your projects without missing important details, losing important papers and thus blowing important deadlines.

The Unimportance of Appearing Organized

Are you a neatnik or a slob? Or do you fall somewhere in between? Relax—there is no right or wrong answer here. It is just important for you to know, recognize and accept your general working habits. While a tidy desk may mean brownie points when you work for someone else, it's far less important when you work on your own.

If you are a crazed, neat person, down to the exact position you leave your mouse on its resting pad every time you quit working at your computer, it's OK, you're not alone. (Compulsive, maybe, but not alone.) If you work like a real pig, old french fry containers under your desk, piles of papers so prolific you can't find the cordless phone, that's OK, too. Accept either scenario and move on.

I have seen many freelancers guilt themselves forever and waste precious time and energy trying to force themselves to change in this regard. When you're working on your own, it doesn't matter one bit. No one else cares. No one else will ever know—unless you show them your studio! Success in freelancing has nothing to do with your neatness habits.

The only time the appearance of your workspace would matter is if and when you ever meet with clients in your studio. In that case, a messy office might offend, although allowances are made to some extent for creative types—just don't push it too far.

The Importance of True Organization

However, you're not going to get off the hook that easily where organization is concerned. Being a neat-freak doesn't mean you are well organized. Many times it means the opposite. I have been known to be such a habitual neat-o-maniac that I have thrown important documents away. Superfluous paperwork, I call it. Unfortunately, that can get you into trouble—especially in freelance situations, with no one but yourself to fall back on.

On the other hand, I know many confirmed slobs who can go directly to the mountainous jungles of their workspaces and pull out just the paper they are referring to—amazing.

Recently, I followed a freelancer out to her car after she told me she had left part of the project there. She seemed a little nervous when I told her I would walk her out since she was in a hurry. When she opened her car door I, who have never been one to keep such things to myself, blurted out my dismay at the interior of her car. I am not exaggerating when I tell you she had the most immense amount of fast-food containers and just plain junk—in my

estimation—everywhere! But I was duly impressed when she pulled out the forgotten board, clean as it could be.

You Alone Are Responsible

Freelancing can be a lonely task, especially because you can't blame anyone but yourself for losing things, nor can anyone but you help find them. Organization goes beyond keeping a handle on where things are. Scheduling, keeping promises (don't you love to count on others who do so?) and making yourself look good only come with the right organizational tactics in place.

Organizational Tools

Different types of organizational tools abound, and you certainly don't need all of them. But before you even think about starting in the freelance business—stop! You will need an actual, physical method for keeping yourself organized, or it will just be a matter of time before you make a huge mistake that will send you running to your nearest office supply store or catalog for those file folders or calendars. Do it *before* mayhem sets in.

The Day Planner

I have to tell you that I thought I was "organization queen" for quite a while after I started freelancing. I kept it all in my head—or on little notes now and then. I did not like the thought of carrying around one of those stupid combination organizer/planner/calendar things that would make me look like every other corporate professional. After all, I was a freelancer. I wanted to look cool and independent.

What it really showed was that I was not very busy, that I did not have a lot of projects going on and that I would be bugging my client over the course of the project for details I was told in the beginning and should have jotted down.

After the jobs started rolling in, I found my once superclean workspace being violated by scribbled-on Post-it Notes—anywhere and everywhere. Even worse was trying to find the right note to go with the right project.

Enter the day planner! I must admit I did not seek out this organization tool on my own. A dear friend, who is also a neat-freak, entered my office, immediately recognized the terror and forced me to go out with her right then and there to buy one. I didn't think I had time to stop what I was doing, buy one of those things and train myself to use it, but we came back to my studio after lunch and she showed me every aspect of this wonderful calendar and how it would change my life. It did.

There are several styles and sizes to choose from. The most important choice you will have to make is which size you will use—do you write big or small? Take a lot of notes? Most meaningful to you will be the area where you list things to do and calls to make on a daily basis.

Again, I cannot begin to tell you the importance of having one of these things. And, no, alas, I do not own stock in any of the smart companies who manufacture these calendars!

Wall Calendars and Job Jackets

In addition to a small hand-held calendar/planner that you will want to carry (everywhere) with you, there are some great wall calendars for your studio. The best kind is the write-on/

9

rub-off variety that offers the most flexibility with your ever-changing schedule. It gives you a great way to visually grasp your current projects—and important dates and details about them—at a glance.

If you have a lot of jobs going at once, you may also want to implement a "job jacket" system. This simply means that for every job in your studio, you have a really large envelope, or jacket, that everything pertaining to the job goes into. This includes any photos or art, copies of notes from your meetings, backup disks or cartridges, etc.

Whichever organizational methods you choose—and I recommend some type of portable planner as the absolute minimum—I promise you it will change your working life forever in a positive way. You will be more efficient and feel accomplished at the end of every day. Clients will be impressed with your timeliness. Consequently, you will have more self-confidence and eliminate those nagging fears of having forgotten "something."

You Still Need to Clean Up Once in a While

One last tip regarding organization: Take an hour or so every week to clean up shop. It makes no difference whether you like to work in sloppy piles or you're the world's biggest neat-freak—do it. (Neatniks often shove things in files and drawers to appear neat, but the stuff is still there!)

You will find things you were too busy to take care of that are still important; you will find that misplaced business card or phone number; and you can also keep on top of clearing out old projects to make way for new ones. Clean old files off your computer (once you're absolutely sure you'll never need them

again), check the ergonomics of your work area and clean the blinds, if you're lucky enough to have a window. Your space will be happier and so will you if you take a small amount of time from your hectic week to get back on track with a clean slate—*knowing* where all your things are, whether they're in sloppy mountains or tucked away in files!

Managing Yourself

Nobody knows you better than you do, right? Freelancing requires an incredible amount of self-knowledge—about your needs for time and space, how prone you are to distraction, how much you procrastinate, your tendencies toward time-consuming perfectionism (or fast but sloppy work when the heat is on). The list goes on and on and can seem totally overwhelming. To achieve ultimate success in freelancing, however, you can't overlook the importance of how you manage *yourself*.

Let's talk about a few self-discipline issues. Can you let the phone ring without answering it? If you get a personal call in the middle of the day can you get out of it (graciously)? If you see a pile of dirty dishes in the sink, can you walk by and into your studio? If you hear one of your favorite tunes on the radio can you keep working without getting up and singing in your air mike while looking in the mirror? I hope you answered a resounding yes to every one of these questions! If you didn't, you've got to work on your self-discipline.

It All Comes Down to Self-Discipline

The very word *self-discipline* can freak out a lot of creative types, but it's only on your behalf

G.A. Wintzer & Son Company, a grease-recycling company, came to us with a budget to do a full-color brochure. Our love for graphic design allowed us to come up with a more creative approach than the typical might have been—the client asked for pictures of mountains, streams and grease traps. We created a more user-friendly solution, choosing to educate Wintzer's customers instead of grossing them out!

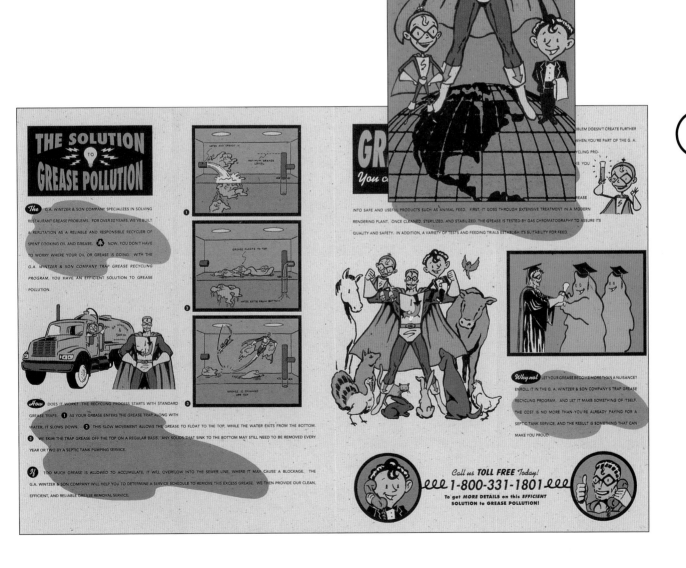

11

PROS AND CONS OF FREELANCING

Pros

- Sleep and work when you want.
- Eat whenever you're hungry, not when your boss tells you it's time for lunch.
- Take as many breaks or vacations as you want; just get your work done when you say you are going to.
- Develop individual style, in your work and the personal image you portray, without playing up to corporate politics.
- Establish your own way of doing things— from how you present your creative work to how you schedule and organize things.
- Meet a lot of interesting people from many different facets of life.
- Learn a lot about yourself and about communicating with others.
- Say no to projects that don't fit your schedule or your personal requirements.
- Make as much money as you want to or as little as you need to.

Cons

- You are always the decision maker.
- There is no one to delegate the bad stuff to. (True, there should be less undesirable work, but once you take on a project, you and you alone will see it through—including the less-than-fun parts.)
- You wait around a lot for the letter carrier when you need money—"paychecks" are never consistent.
- You have to pay for your own equipment, entry fees in awards competitions, business lunches—everything! (Fortunately, it's all at least partially tax-deductible.)
- You have to meet the deadlines you set up in the first place.
- You will have to do clerical, janitorial and troubleshooting work.
- You have to learn how to say no.

that I even bring up this horrific word that suggests obedience to authority and rules. Remember—the only rules you'll have to follow are the ones you absolutely need to get your work done. No one else will be enforcing random rules.

When I started freelancing, my neatnik behavior did not allow me to enter my studio until every inch of my surrounding living space was impeccable. If my mom called and wanted to take me to my favorite breakfast house, I was gone before we had even agreed on a time to meet. If the phone rang, I refused to let my machine get it, telling myself the machine was rude, even though 99 percent of the rest

of the world was on voice mail. The hardest thing was the realization that I could not work and play music—which I love—at the same time. I simply had to put my air microphone away and resign myself to rock-and-roll antics during my off hours.

Believe me, I tested myself a zillion times. Maybe if I just played the stereo softer. Maybe if I wore a headset to talk on the phone. But learning self-discipline isn't about lying to yourself or making your bad habits easier to justify! Being a successful freelancer relies heavily on giving yourself the upper hand. Once you have a handle on your good and bad habits you can use them to your advantage.

For example, set some goals every day before you get started, and when you meet your goals, give yourself a small reward. Lots of times I would tell myself I could go out to eat or turn the radio on for an hour as soon as I got XYZ done. Setting up little motivations for yourself is a good way to get going.

Quality vs. Quantity

How do you decide how much work you can take on and which projects to do? Let's talk about the old quality vs. quantity cliché. One of my closest colleagues drives me crazy with a little saying he always has: "Quality is long remembered after price has been forgotten." But it's true. Think about it. If you buy an all-cotton sweater, say, instead of one that's 50 percent cotton, 50 percent polyester, you will notice how much nicer and longer the 100 percent cotton sweater wears. It does not get fuzz balls. It feels better. Maybe you paid a few bucks more, but after the money is spent, a few weeks or months down the road, do you remember—or care?

Freelancing is a comparable situation in at least two ways. First, consider the types of projects you want to do vs. the quantity you need to do to make a profit. Maybe at the beginning of your freelance career you take any and all projects that come your way just to get your name out there. You take work that's less appealing (a lower quality, at least in your eyes) to get enough quantity. Or maybe you don't, if you don't have to establish yourself that quickly.

A second quality vs. quantity comparison is in how much work you can get done vs. the quality of that work. Here there's less choice. If you absolutely love doing a lot of projects at the same time, if you think you do your best

work when you are overloaded (and a lot of us are that way), if you love teetering on the edge of sanity—go for it! But if too much work will erode the quality of what you're doing—and you'll soon know if this is the case—be careful.

My strictest advice regarding quality vs. quantity is that you create and produce every single project that comes your way to the utmost of your capabilities. Don't rationalize that "It's just a small project" or "It's pro bono—I didn't make any money on it, anyway." If you commit to a project, make sure you have the time and self-discipline to give it your all.

Managing Your Time

What about the hours you keep? Do you burn the midnight oil—all the time? Does it seem that you never have enough time to play? Do you sometimes wish you had a "real" job? If this is you, wake up! You and only you are in control of your freelance destiny. If you find yourself working harder and longer hours than your nonfreelancer friends, chances are you are either taking on too much work or you are simply not disciplined enough. Try to get objective feedback from those close to you—roommates, friends, parents—if you absolutely cannot figure out on your own what is going astray.

The most wonderful and rewarding thing about freelancing is the freedom that goes with it. There is no reason to become a slave to it. Creative freedom, setting your own schedule, working at your own pace and establishing your own niche, style and methods of offering your services are all assets. If you feel encumbered with freelancing, you need more streetwise skills.

13

Photo by: Jaume Mateau

Adolfo Martinez-Perez
On Being a Freelancer

Adolfo Martinez-Perez has been a freelance storyboard artist for more than ten years. He has worked on major motion pictures such as *Timecop, Courage Under Fire* and *My Fellow Americans.* He also does storyboards for popular television series, CD-ROMs and television promotions. His work is produced conventionally, not on computer.

1. Why did you become a freelance artist?

Freelancing chose me, rather than the other way around. My personal skills and background qualified me for a very specific field—storyboards. There are few companies or studios with a staff of artists to provide storyboard services. The closest equivalents are agencies that represent artists who work on a freelance basis.

2. Do you work on more than one project at a time? If so, what is the biggest challenge of balancing so many requirements, and how do you deal with that challenge?

I try not to work on multiple projects. Storyboarding usually requires a full-time commitment, working against the clock. There is not much time for simultaneous jobs. The only instances when I have done so are (a) When I was offered a project that I personally liked and the client couldn't afford

my regular rate. I explained that other projects were a priority. I worked on their project on the side to fill up my schedule. I developed it between regular-paying projects, on weekends, etc. I don't need to fill up my schedule currently, and do not take a project anywhere below my rate. (b) When unexpected revisions of an already finished project overlap with the next one. In this case, my agency explains that I'm unavailable and offers the services of another artist. Or I personally recommend another artist. If they persist, or if I feel a personal commitment to the project, I may do two projects at once—as long as I will not be hurting the second client.

In either case, I must sacrifice sleeping time so that I could put enough time and energy in both projects. I realized after working with sleep deprivation so many times that I can only recover from a schedule like that with extensive rest

afterwards. I decided never to put myself in a position where the only way to ensure fairness to all of my clients would by denying things to myself. You can't compromise your health and your ability to perform your skill because of the inability to explain that you are not available. Doing it out of greed would be even dumber.

3. How do you keep yourself organized in general?

My agent manages my schedule to maximize my time and prevent double booking. I also have a whole-year wall calendar with the months in horizontal strips, where I indicate appointments and where I keep record of each job performed by using a color code for payment collection status. This helps at the end of the year because I file it with my tax return paperwork. A Rolodex file is also very helpful.

I also have a one-sheet management form that I designed myself. It folds up into pocket

14

size and is the only piece of paper that I need to carry! I produce them on my computer and keep the used ones for tax purposes. One side displays a four-week calendar where I indicate any activity or appointment that can be scheduled. On the other side I list tasks or commitments that can be performed at any time. It also holds a list of everything that I lend or borrow to or from anybody, so I can actually lend or borrow with complete peace of mind—books, music and films. I also keep a business card-sized phone number list in my wallet that holds over 120 entries!

4. How do you maintain your self-discipline to stay on track and meet deadlines?

I give myself and my clients very tight deadline estimates, committing to check periodically with them. I also work with a stopwatch in front of me and reset it after I finish each storyboard frame to find out how long I take to complete each drawing. This helps me to determine pricing for future estimates, which are based on my time. I recalculate daily (or sometimes twice a day) while I am working on specific projects so that I know if I am ahead of schedule or behind. I adjust my daily schedule accordingly. The more estimates I do, the better I become at establishing good schedules.

5. What do you think is the best thing about freelancing? The worst?

Depending on who the client is, the best can be the worst and vice versa! My goal is obtaining

a special type of project, and that is more important to me than being my own boss. I am more fit for the "performance" of freelancing rather than the management of it, so I have an agency that represents me. It can be expensive, but it increases the overall quality of my life by allowing me to concentrate on what I enjoy and do best, while still keeping me without a boss.

6. How do you keep your self-esteem up?

There is an old cliché that says making the first million is the hardest and that all the others come by themselves. The same could be said about building up self-esteem. The tough part is acquiring it in the first place. Failures or lack of opportunities can be used as motivational devices for self improvement. Using pride to trigger constructive reaction is one way I have built up self-esteem.

When I started in the industry, it was hard to see people less proficient than me obtain work simply because they had a history of creating work for the movie industry—not necessarily because they were the best. I also learned a lot from rare occasions when a client expected more than I delivered. I recovered my confidence by comparing the unreasonable client incident to the overwhelming success with the rest of my clients. Finding yourself out of sync with your client could lead to you being absolutely unable to satisfy them no matter how hard you try. I try to be aware of my synergy with a director before I agree to do

work for them. I don't give them the hard sell just to get the work if I don't feel good about it.

7. Can you tell when you get burnt out, and what do you do about it?

I only get burnt out when I don't enjoy what I am doing or when there is a lack of challenge to my creative thinking. It can make me feel reduced to a drawing machine and not feel appreciated. A complete lack of response when I deliver very satisfactory work can also be very alienating. I deal with it by waiting until the project is over. Once I have made a wrong choice I have to live with it. Projects don't last forever, and the chance of embarking in a very long project that is wrong for me is very minimal because of the way I use common sense in choosing my work.

When a project is long or repetitious and I find myself getting bored, I challenge myself to find ways to maximize my performance. Learning to use a new material or focusing specifically on the expression of my characters, for example, can help distract me from something I am bored with. You can always find that little something that keeps it challenging. It will help you deliver your best work.

8. How do you approach your clients—Easy going? Aggressive? Please describe why you use the approach that you do and why it works.

The way I approach clients is all business. Being aggressive or too eager to impress doesn't work in my field. You need to learn where your place is.

15

Directors in the film industry for whom I work need to bring out their own vision through all the collaborators they have chosen. I do not add to the overall pressure, even if my ideas are good, if I think it will be a struggle with the director.

I strongly advise the "all business/talk-when-asked" approach to anyone who is starting out in the industry. In school, speaking up and showing initiative is encouraged; but in the freelance industry it can become self-defeating and make you look naive, unprofessional and give away your lack of experience.

I don't feel comfortable being "buddies" with directors. I keep my distance without appearing unfriendly. Keeping distances makes it easy for me to be seen as functional and effective and helps me establish my professional worthiness. I make sure I am not uptight with clients, though, because that would make me look as if I don't care or I am arrogant, contemptuous or intimidating. I know when to smile.

9. Do you freelance because (a) you love it, (b) the pay is good, (c) it is a powerful way to express yourself, or (d) all three reasons?
As I said before, freelancing chose me rather than the other way around. My goals are connected with the activity and types of projects that I have access to. Since I was able to disengage myself from those aspects of freelancing that I like the least, having an agent has allowed me to show up and draw, which fulfills me most. My rates are based on my history and by what the production company can afford to pay.

10. What is the most important thing you have to share with our readers regarding their becoming freelancers?
My view, based more in common sense, is that you need to have a certain personal nature to enjoy it and be good at it. Very often people with an artistic temperament are the least suited to deal with the management part of freelancing, but those people are probably the ones to find the best chance to practice what they enjoy by being their own bosses. In any case, there is no harm in trying and finding out how it feels. Many an artist may be surprised to discover his or her hidden managerial potential.

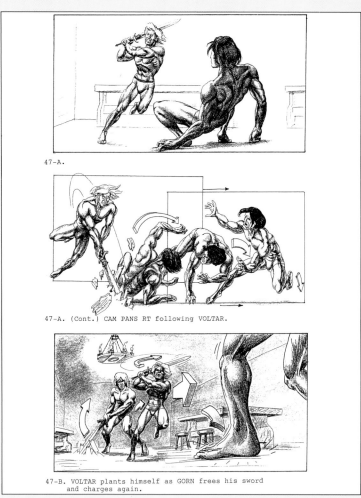

47-A.

47-A. (Cont.) CAM PANS RT following VOLTAR.

47-B. VOLTAR plants himself as GORN frees his sword and charges again.

Three-frame board

ONCOMING CAR SKIDS AND STOPS SIDEWAYS ON ROAD (TIRES → DUST CLOUD) CAM PANS AND TILTS TO FOLLOW (HIGH ANGLE, IN CASE CAR SKIDS TOO FAR)

MACHINE GUN BLASTS GLARE THROUGH CLEARING DUST CLOUD, AS CAM. TILTS UP TO REFRAME FOR FRANK, WHO LEANS FORWARD (OVER HEATHER)

CAM BOOMS UP TO REVEAL APPROACHING BIKERS IN THE B.G.

BIKER #3 IS HIT (LONG LENS SHOT)

(SEEN THROUGH FG. GLARE FROM MACHINEGUN'S FIRE) C.U. FRANK (SHELLS FLY IN FRONT)

BIKER #2 IS HIT (REMOTE CAM. UNDER PLEXI RAMP, FOR PROTECTION)

Six-frame board

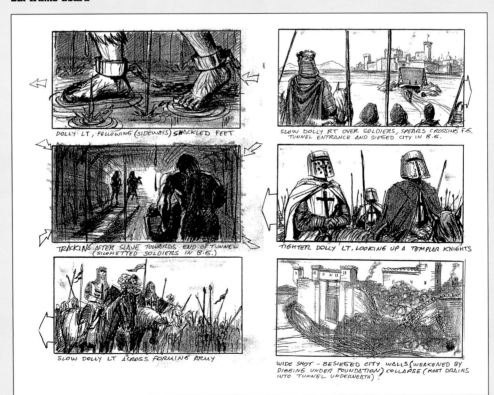

DOLLY LT, FOLLOWING (SIDEWAYS) SHACKLED FEET

SLOW DOLLY RT OVER SOLDIERS, SPEARS CROSSING F.G. TUNNEL ENTRANCE AND SIEGED CITY IN B.G.

TRACKING AFTER SLAVE TOWARDS END OF TUNNEL (SILHOUETTED SOLDIERS IN B.G.)

TIGHTER DOLLY LT, LOOKING UP AT TEMPLAR KNIGHTS

SLOW DOLLY LT ACROSS FORMING ARMY

WIDE SHOT - BESIEGED CITY WALLS (WEAKENED BY DIGGING UNDER FOUNDATION) COLLAPSE (MOAT DRAINS INTO TUNNEL UNDERNEATH)

Six-frame board

Dressing the Part

Being streetwise requires not only that you produce great freelance work, but also that you have the right image while you're doing it—including how you dress the part.

Establishing personal style is all part of the self-discipline regime. You want your clients to be comfortable with you as soon as possible, but for the most part, it will be impossible to be personally familiar with clients before you produce the work. So use some of the old "dress for success" advice, but update it for the times and for your role as a creative professional.

What exactly does this mean? First pay attention to what your clients are actually wearing, not just what you think they will be wearing. Even big businesses today are often dressing "business casual" every day. This does not mean that jeans, T-shirts or running suits are acceptable (although I am certain that you will see them all from time to time). I have always dressed business casual myself, almost every day since I started my own business—even before most of my larger clients went business casual.

I also think all of us like to look "current," even though that may mean different things to different people. Since our business has a lot to do with trends, colors and style, you'll often be expected to show abilities with these qualities in your wardrobe. I have found that many clients expect designers and creative types to dress "a little weird." Some have told me they actually look forward to this. It's fun for them to live a little vicariously, especially when they are looking for new, creative ways to communicate their company's products or services.

Of course, there are times when dressier attire is necessary. Especially when talking to financial types—bankers, accountants, insurance professionals. People in these professions need to be taken seriously in their line of work and will take *you* more seriously if you dress on the conservative side.

Developing Self-Confidence

How do you build adequate self-confidence to be a successful freelancer? The key word here

EGO: THE GOOD, THE BAD AND THE UGLY

A supremely healthy ego is vital to survival of the fittest freelancers in today's world. Just make sure your ego isn't blown up so huge you can't get into your studio door. Know the importance of taking criticism constructively, not personally. Know how to take responsibility for your actions when you've made a mistake—and when you've done something great!

There is nothing worse than creative types whose egos will not allow them to see the reality of a situation. If you find yourself feeling attacked by many of your peers and clients, if you find yourself wondering why no one agrees with you, if you find yourself not getting the projects you have aspired to, take a good hard look at your ego. You will probably find that it needs an adjustment.

It's not often that we are totally "right" and absolutely everyone around us is "wrong." The great thing about attitude/ego adjustment is that you will find people will respond to self-improvements immediately. It is also healthy for colleagues to hear straight from you that you are doing some introspective searching to see if some behavior adjustments might be necessary. This generally comes as a huge relief to all parties, but especially to you when you see the positive results and responses.

is *successful*. Success, of course, is a subjective thing, but you have to know what *you* mean by success. It is important to define success for yourself at fairly regular intervals if you're going to succeed at anything.

At the beginning of every month I like to sit down with my calendar/planner and think about the things I could accomplish that would give me, in my mind, a successful month. I find that for the months when I do not clearly define these opportunities for success, I end the month feeling frustrated and unaccomplished, even though when I go back through my calendar, I can see that I really did get a lot done. A lack of definition is always my stumbling block, and it's a very common one. Try this method for two months and you'll see what I mean.

Set Goals and Make Lists

All of this goal planning or list making shouldn't take more than about fifteen min-

utes. Some of the items may carry over from the month before—you now have a full month to try again! Personal goals, as well as business goals, may cross over onto this list, and that's perfectly all right. Being a freelancer means that you are constantly melding your personal time (and life) with your professional time.

Once you start setting goals and meeting them, you won't question yourself and your actions nearly as often. The purpose of this monthly planning is not to overwhelm yourself with an unreasonable schedule or too many demands. It is simply to list things that you are committed to accomplishing and that you actually *want* to accomplish. Periodically throughout the month you should look at this list and see where you are (or aren't). That way, facing an unfinished list won't come as such a shock at the end of the month! Being a freelancer requires incredible amounts of independence, and it's up to you to build

structure into your work and life if you are going to succeed.

The bigger objective here is to build self-confidence. You are in control of making the list (setting your goals); you are in control of checking it every so often as a self-status mechanism; you are the one who accomplishes or completes the desired actions. Voilà! Self-confidence is born.

Start out with short lists. You may have as few as four items for the entire month. Make your attempts at accomplishment achievable, and once you realize that four things are achievable, increase the quality of the achievements (there's that quality vs. quantity thing again) so you constantly challenge yourself.

How to Handle Your Critics

So you have cynics all around you, you say? Cynical folk, especially those willing to be pessimistic about *your* plans, are everywhere. I offer one strong piece of advice to those of you desperately yearning to be successful freelancers, but feeling overwhelmed by critical words (or actions) from friends and/or family: *Don't listen to them!*

Easier said than done, I know. And I had a more encouraging start than most people do. When I was young, my mother consistently encouraged me with the opinion, "You can do anything you put your mind to, anything!" Little did I know that as I grew older the harsh comments of people other than my mother would infiltrate my brain, causing questions, concerns and self-doubt.

There was the paddle-happy art teacher in grade school who refused to acknowledge my artwork as being any better than that of the math genius who sat near me and had, in my opinion, no idea that red meant any-

thing other than the ketchup on his soy burger.

Then there was the incident at the very beginning of my freelance career, when even my mother was nervous about how I was going to pay my bills. She encouraged me to meet the son of a girlfriend of hers who was starting a new design firm in town. This man had always been my idol; his illustrations were incredible, he had gotten art scholarships to the most prestigious schools, his work had appeared in countless annuals. When I finally got the courage to call him for an interview I was a nervous wreck. He proceeded to deflate my total being by telling me my portfolio was very weak and that he doubted if I would ever make it in the competitive freelance environment.

I could hardly get out to my car before the tears of self-pity overflowed. If I had taken my self-confidence into that appointment, things may have turned out differently. But most of us take far too many of our cues from a handful of people who happen to be very influential at critical points in our lives. We're influenced by our parents, our teachers, and maybe one or two professionals whose opinion means *everything* at the time. At some point, you have to give yourself the confidence you need. I came to realize that I had built no real "professional" self-confidence at all. The only self-confidence I had was what my mother and subsequent teachers (except for the paddler!) had given me; I had given myself nothing along the way.

Know Your Strengths and Weaknesses

These two experiences with cynics could have squashed me into the depths of burger

A MEANS OF SOARING TO GREATER HEIGHTS

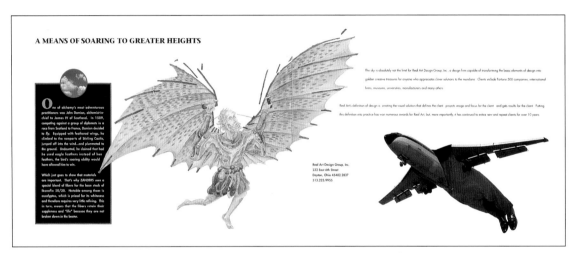

ALCHEMY

A quest for perfection – then and now.

When Zanders Paper Company came out with a new recycled coated sheet, we jumped at the chance to gain some promotional power by providing design services, featuring some unique production techniques for this highly respected paper company. The outcome won us many awards—thus the "power" we were looking for. (Certainly we did not do this project for money; paper companies are notorious for having very low budgets—or no budgets—to work with.)

21

flipping for the rest of my life. But I decided to pick myself up, dust myself off and take an objective look at the strengths I did have, and I built myself up from there.

Take some time to list your strengths and weaknesses. If you stay focused on what these are, you will be able to steer yourself away from cynics who will question everything about you. More importantly, your strengths will lead you to items to put on your monthly accomplishment lists. You can also use your weaknesses list monthly to see how you can eliminate some of these attributes once and for all.

How to Handle Success

The key here is learning not to share your deepest, darkest secrets with everyone; save these for your nearest, dearest friends. Don't talk about how much money you do or don't make. Don't be a whiner or a complainer. At the same time, don't brag about your accomplishments or flaunt your independence in front of your acquaintances. Keep it cool and to yourself. Many of your clients' and colleagues' attitudes toward you will be based on the attitude you project about yourself and the attitude and respect you share with them.

I know that being a freelancer means spending considerable time alone. Sometimes when you meet a client and you have a lot in common, it is easy to feel as though the client is a friend. There is nothing wrong with developing friendships with clients. It is important, however, to let these friendships develop slowly. Don't overwhelm others with your professional upswings or downswings. You'll find people running for the door. Save these conversations for your cat, dog or loved one—and make sure you have plenty of treats to pass

around after you're done as an acknowledgment of their well-spent time listening to you.

In that same vein, it is important to project your newfound self-confidence in a calm and easygoing manner rather than by being overly aggressive. Especially in the freelance creative industry, in which peers and clients are under a lot of their own pressure to meet deadlines and develop creative solutions, the last thing anyone needs is a freelancer who pushes an over-inflated attitude around like it's a hot air balloon on a bad course! The great part about your new attitude and self-confidence is that once you develop it, it's there forever. Like riding a bicycle, you never forget how to be self-confident once you learn it.

Everyone Likes a Winner

When I started freelancing, a dear friend of mine gave me some advice that I will never forget: "Everyone likes to go with a winner, Theo." She shared this insight with me as I agonized over whether to buy a newer car to replace the unreliable rust bomb I was driving around in.

Granted, talk of a new car seems superficial, but her advice was not. I thought that being a freelancer, I should be poor, people should feel sorry for me and I should basically follow in the footsteps of starving artists. The truth of the matter is the opposite; people indeed like to go with a winner. Winners use their attitude in a positive way toward associates (without letting their self-confidence become so overbearing that they talk about how much the new car cost!). Furthermore, most of the freelance designers and illustrators I know do make very good money. There is no reason to feel sorry for them.

The Rewards of Life as a Freelancer

Many people ask me what the rewards of freelancing are. Now that I have a full-service design firm with many employees, two business partners and a portfolio stuffed with accomplishments, that question is easier to answer than it was when I was just starting out.

Mostly, the rewards for me came from the amount of unstructured time I had and how I managed that. Of course, there were countless projects to conceive and produce along the way. But it was so much fun to decide on a weekly, and even daily, basis how much time went into the actual studio work vs. how much time was spent outside nurturing my creative spirit with photography and drawing. Meetings, office politics, and some of the other demands of a 9-to-5 job were delightfully absent. Take the word *free* in freelancing and know that freedom of many types is the biggest gift that freelancers cherish.

Chapter 2

How to Set Up Your Freelance Studio

Creating a professional surrounding for yourself is important from the very first day you begin freelancing. It's pretty much a given that if you are leasing real studio space, you will have your name on the building's list of tenants or perhaps even special signage that introduces your business. But what happens when you work from home, like most freelancers?

Master the Environment

First of all, working from home is absolutely, completely and totally acceptable. It is nothing to hide behind and something you can even be proud of. In fact, it is more and more common for freelancers to have studios in their apartments or homes. As our society turns to this new age of computer/technological wizardry, the design industry is turning the corner into a more advanced age of its own.

Ours was one of the first industries to completely embrace computer technology, and within the period of just a few years in the mid-1980s, it evolved into a comprehensive way of doing business. No more drafting tables, clogging tech pens or marker comps; I can honestly say I don't know any of us who aren't thrilled about it. The computer has given us pure and complete freedom and, therefore, every reason in the world to freelance—from our homes!

Remember when your parents used to hearken back to "the good old days" and you could feel your eyes rolling back into your skull? Well, since this book offers true-to-life "street smarts" I have a little one of those mom-and-pop stories myself. Please try to keep in mind that I will eventually make my point clear.

A Short History—With a Happy Ending

I started my freelance business in 1983. I lived in a small one-bedroom apartment and was

forced to sacrifice the luxury of a double bed for a twin-sized model so I could accommodate my drafting table, taboret and assortment of art supplies within the confines of my bedroom. Needless to say, my cats were stricken meowless by the sudden lack of lounging space.

Eleven months and several good projects later, I bought a fixer-upper (a nonfiction trauma documentary for another day) that offered more space, allowing me to have a separate room for my studio. Several more months went by. Projects became more substantial. Then (horrors!) came the project I had been waiting for that finally allowed me to handle a decent-sized press run. Suddenly I had printers calling me from all corners of the Ohio Valley.

Answering my phone in my most professional manner, I didn't dare let on that I was working from my home. At that time, I knew absolutely no one who worked from home. If you were anybody at all in the creative industry in a small, cheap-rent town like Dayton, Ohio, you emphatically did not work from home. Well, I did.

The point to my story is this: The one printer who stood behind me, pored over proofs with me at my dining room table and treated me like a multibillion dollar Madison Avenue client is today, fifteen years later, one of my firm's favorite vendors. He not only has made a ton of money from printing many of our projects, but also has won several awards in his own industry from printing pieces we have designed, has gained new clients from referrals we have given him and, last but not least, has eaten some pretty good breakfast pastries while waiting for one of our artists to finish a job he is picking up!

In 1983 it was unusual for people to work from home. I got a lot of quizzical expressions from neighbors because of the weird hours the lights were on and the car sped away from the curb for third-shift press proofs or quick-print shop runs. Now it's not unusual for people to work from home. Several of my white-collar executive colleagues have three- or four-day workweeks in exchange for keeping a home office and a committed connection to the office on their off days. It's "cool" to work from home now, so enjoy it—and promote it!

Create a Professional Environment

Creating a professional environment is more for your own good than that of your clients. I have had many freelancers argue with me that their clients never come to visit them in their studios, so why make it professional? My answer is that the impact of having a professional environment is purely psychological. Perhaps being professional is subjective; to me it means cleaning up after you've had a snack at your desk, not leaving dirty laundry on the floor, cleaning up at least once a week and being organized (which we talked about in chapter one). I promise you that if you set up a professional workplace, you will be more productive, have more self-respect and self-esteem, and when you close the door after a hard day's or night's work to go "home," you will feel a difference psychologically.

Another aspect of working in a professional environment is the color of your space. As designers, we all know the value of using just the right colors for our projects. We sell many clients on color theory we learned in design school. Using that same theory for ourselves seems elementary perhaps; however, many small home studios I have walked into were not designed with color theory in mind at all.

25

Take, for example, a friend of mine who used her baby's nursery for a studio after her daughter graduated to a "big people's bed" and moved to a larger room in the house. How can you take yourself seriously as a designer if you are staring at ABC wallpaper with pink, blue and yellow curlicues all over the place? An evening of diligent labor between the two of us brought down the baby wallpaper border and the pastel paint scheme. The end result cost less than $200, including some new mini-blinds, fresh white paint, freshly mounted posters my friend had designed and a new floor lamp that swings every which way.

Choosing the color of your walls may also seem like a subjective decision. We all know that the color red is usually a precursor for caution or excitement. But maybe red is your favorite color and you like to be hyped up while you're in the studio. That's OK (although you might try just one wall before you try all four!). Just make sure you recognize that wall color will play an even more important role in your productivity than that same color might on page fourteen of your client's brochure.

If freelancing is going to be your business, treat it as such. Don't punish yourself because you are working from home or sacrifice spending a little money to change a baby room or spare room into your studio. Make it a priority to have that room reflect your personal tastes and style.

Lighting and Ergonomics

Probably the biggest utilitarian mistake I see with freelancers' spaces is poor usage of lighting. Because we are designers, illustrators and creative types, I think we expect too much from ourselves as far as interior design goes. People actually go to school to become interior designers and architects. I think that fact surprises most of us at the graphics end. Good lighting is key not only to seeing what's in front of you, but also to preventing fatigue. A poorly lit room enlarges your pupils and, eventually, makes you sleepy. Many overhead fluorescent lights have a hum or cast a green shadow that will ultimately have the same effect.

Consult your local lighting showroom. The interior designers who work at these places specialize in lighting. Take a simple sketch of your studio space layout, showing where windows are and indicating any existing lighting type. Share your work habits (Do you work in the daytime, or do you pull a lot of all-nighters?) and seek recommendations from these lighting pros.

When I first began freelancing, I didn't think I could afford to do anything like this. Pinching pennies and cutting back was certainly a priority. When I finally went into a lighting store nearby, I was amazed at the different types of affordable lightbulbs and fixtures available that would be of great functionality for my studio.

Also, in the functionality category is good ergonomics. Again, let the pros help. People who sell desks and office/computer furniture love to share information about seat height, keyboard levels, etc. These issues are becoming exceedingly important as we spend more time at the computer. Tell your salesperson how much time you spend at your monitor, telephone, etc. Go to more than one place and get more than one opinion. Don't buy anything until you have a lot of information and feel confident enough to decide what will work best for you.

Setting Limits

Mastering your home freelance environment also includes learning to set limits with those

26

people sharing your space. This means everyone from the family pets to your best friends who don't even live with you to those nearest and dearest to your heart. Know that it is not selfish to make your freelance space completely off-limits to anyone (or anything!) except you. I have found that this is the absolute best way to not invite trouble to your door.

If kids, dogs or friends must enter, they should never do so with food, beverage or loud disruption. You may be on the phone with an important client, you may have a portable heater plugged into an extension cord that would send a visitor careening through the air (thus, the no food or drink rule) or you may be concentrating so intensely that an interruption could either make you forget the wonderful idea you just had, or give you a heart attack. Just set rules that work for you and stick to them.

Children and spouses may need a heart-to-heart talk about the fact that this space is where you make your money and how you pay your bills. It is so easy for others to unknowingly disrespect your time or space simply because they know you are in there. Asking for what you need will relieve your anxieties and clearly set forth expectations to those sharing your environment, which will ultimately bring you more respect from those you care most about.

When Working at Home Doesn't Work Anymore

Growing out of working at home is not necessarily the greatest thing that can happen to a freelancer. In my own history it was very much an oxymoron. Gone are the days of true freelance freedom. Managing other people and far more situations than you ever thought possible can be overwhelming and frustrating. Fourteen years later, I am not sorry. But to be quite honest, many of the in-between years were spent longing for my old home studio when times were simpler.

You know you've grown out of working from home when . . .

• The phone rings so incessantly that you can no longer be productive because you are constantly answering your business line. Solution: You need a receptionist/office manager.

• You spend most of the day doing clerical work. Solution: Same as above.

• You spend most of your day in meetings with clients or vendors, which results in working in your studio all night, which results in complete breakdown. Solution: You need an assistant who is skilled at your profession and can help you with some of these meetings.

• You've tried and tried but you get no respect at home. You have six kids who constantly interrupt, and your significant other is frustrated because you are "home" all of the time but nothing around the house is getting done. Solution: You need a family counselor.

Don't get me wrong about leaving your home base for a larger studio. It can be a wonderful, rewarding experience to open a real studio with a sign outside and employees to foster. It's just that the wonderful aspect of being totally on your own will be a thing of the past, and a much larger commitment to business requires more time, fragmentation of creativity and a concentrated effort on profitability.

27

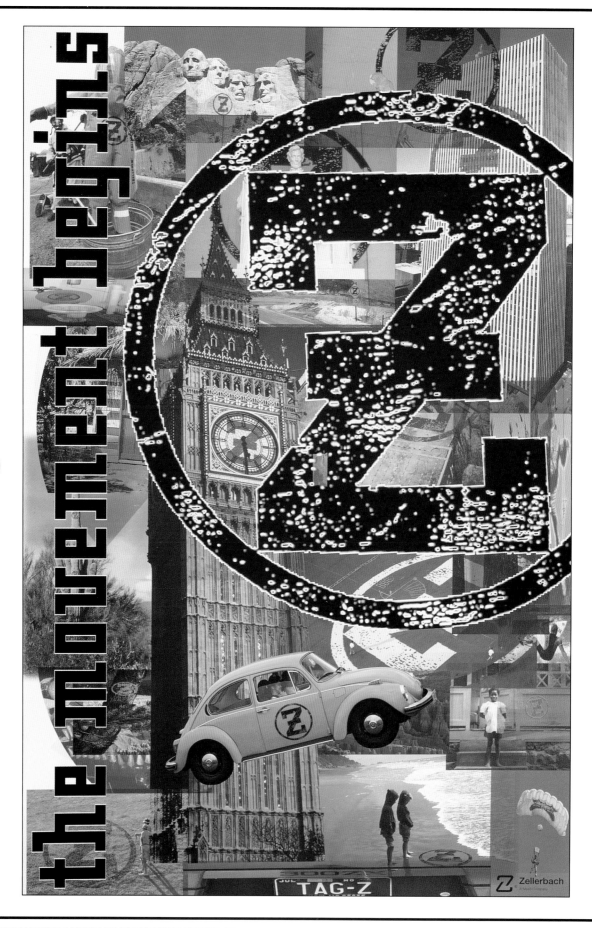

the movement continues

We designed and produced this promotion for Zellerbach many moons ago when Adobe Photoshop was fairly new. The size of the finished art file was so huge, we had to rent an external 1-gigabyte hard drive just to get it to the color separator! Since then our equipment has quadrupled in size of memory and technical capabilities.

HOW TO SET UP THE IDEAL SPACE THAT WORKS FOR YOU— A CHECKLIST

❑ Take a survey of your existing home. Is there a room that could be entirely designated to your freelance business?

❑ Is there a door on the room?

❑ Is there a phone line in the room?

❑ Is the room located in an area of your home where you will have privacy?

❑ Do you know what colors motivate you?

❑ Have you shopped for the proper task lighting?

❑ Are you committed to purchasing ergonomically correct furniture?

The answer to all of these questions must be *yes*, emphatically!

These issues are purely environmental but have a very big impact on the longevity of your freelance career. Skimping on the details now will lead to your personal discomfort sooner than later. The aftereffects will find you discouraged and wondering what you did wrong as you look for a job in the regular workforce again.

Choosing and Paying for Equipment

It's great that our industry embraced computer technology so completely. Now those of us who had a vision for a great illustration—but perhaps not the greatest of hand skills—can draw some pretty nice illustrations with the help of our computers. No longer do we suffer the throbbing pain of the craft knife-sliced finger. The agony of dropping your technical pen square onto the hardwood floor, resulting in a smashed nib at midnight with all the art supply stores closed, is gone.

Establishing a Budget

New problems facing freelance designers and illustrators include the larger budgets we need to set up shop. My biggest piece of advice is to not get overwhelmed. First establish a budget for yourself, then set your priorities. Stay current on the latest and greatest hardware and software options on the market by subscribing to an industry magazine (which you should be doing anyway) or by attending trade shows at least once a year. I find that magazines are the most useful, since I prefer to spend my travel time (and money!) on vacations. And, when I'm traveling on business, there's nothing like a warm and friendly trade magazine to help the time go by.

How do you establish a budget when you have no money? Well, I'll be honest: If you truly have no money, then you really should not start freelancing. This may seem harsh, and I'm sure many of you might argue with my opinion, but I'm being realistic. And there are ways for you to get money—such as eliminating your car payment. Sell the newer car you have and pay cash for a "bomb" temporarily until you have built up enough cash to buy a more modest, newer car. Statistics show that many of us, especially in larger markets,

drive cars beyond our means.

Pay off your credit cards before starting your freelance business. The best way to start a freelance business that you commit to for the long term is to plan for it. Set a goal date for its inception, depending on your debt load. Most of us leave nice-paying positions to join the ranks of freelancers. Use the nice pay to pay off your indebtedness, not to buy luxurious cars, trips (for the moment, anyway) or clothes (buy three really nice outfits—the same people are not going to see you every day).

Your startup budget should include money for two months' worth of expenses—everything from your mortgage to goldfish food. Don't forget food for yourself, the occasional night out and another 15 percent above your normal expenses as a safety net. Not having an adequate budget or working capital to start out is yet another precursor to early failure. Obtaining the right capital and getting "funded" are easier than you think. Read on!

Stretching Your Dollars

Now is the time to scout out possible third-party services in your area that will help you buy hardware and software. Don't commit to any of these services until you have thoroughly checked their referrals and the Better Business Bureau to make sure they are credible.

The best way to locate these third-party people is to ask your peers if they know anyone who might help you with making decisions about computer purchases. These services can actually save you money because many of them are authorized equipment dealers or have volume deals established with some of the larger suppliers.

Third-party services are also excellent

sources for used equipment because most of these services also offer repair expertise. Used equipment that you learn about from peers or your local classifieds can be qualified as good or bad buys for a nominal fee from these services. It's like taking a used car to an auto mechanic for a clean bill of health before you buy it.

Another great way to make your money go farther is to purchase via mail-order catalog. Pick up a computer magazine that offers feature articles on the brand you are interested in purchasing. Use the reader service card in the magazine to inquire about mail-order opportunities for equipment that interests you. Respond to ads in the back of the magazine that promote equipment via mail order. Within thirty days you will be deluged with possibilities. Make sure the warranty offered by these companies is the same one you would receive buying directly off the shelf. I have saved up to 40 percent buying hardware and software this way.

Creative Financing

Another option is to do a little creative financing of your own. The great thing about needing to make computer or office furniture purchases is that competition is fierce. Most computer and furniture stores have one-year-same-as-cash deals or no-payment-for-a-year deals. For less than $125/month you can have everything you'll need to get started in the freelance business—really!

These special deals are truly OK if you don't let yourself get beaten up over them. This goes back to the D-word from chapter one—discipline. If you do one of those one-year-same-as-cash deals, make a plan to pay off your equipment in one year if you can swing it.

Photo by: Katherine Criss, NYC

Jan MacDougall
On Being a Freelancer

Jan MacDougall was a freelance designer/ illustrator from 1977 to 1984, creating book covers, educational materials and sales promotion literature. After being an art director for the next seven years at Chapman Stone & Adler (a division of Young and Rubicam), where she worked for such clients as IBM, Met Life, the U.S. Postal Service and Chase Manhattan Bank, Jan returned to freelancing. She currently creates illustrations for Simon & Schuster Publishers, NBC News and Chemical Bank (to name just a few) and is very active in freelance design and art direction for an impressive client list.

1. You were an ad agency art director. Why does freelancing work better for you?
I prefer the variety of work that I'm able to do as a freelancer. I've found that there is a lot more creative freedom in working for myself. I also have direct client contact, which I enjoy and didn't always have at the agency. I work longer hours as a freelancer, but I thrive on the flexibility it offers. And I like feeling in control of the direction that I'm heading. I've concentrated on illustration and design projects rather than strict advertising assignments.

2. Do you work at home or in a separate studio?
Sometimes I will work on site for specific projects, but the majority of my work is done in my home studio. To date, the home situation has worked out

well. I haven't wanted to set up a separate studio for a few reasons. One is that I've wanted to avoid the added expense, which in New York City can be substantial. I also tend to work a lot at night and prefer being at home for that. I also enjoy having my cats, Tibbi and Amanda, around. (I also have two parakeets, an aquarium and many plants! I probably would be in heaven setting up a studio in an old farmhouse with a cow and a few sheep outside . . .) I live in a studio apartment on the Upper East Side. It's a great location for getting around the city and a nice neighborhood. I could probably use more space to store files and such. And a bedroom or den would be nice to be able to separate work from real life at the end of the day, but I'm creative with how things are set up and content for

now. Circumstances will dictate when I've completely outgrown the space. I don't feel that working in my home really affects my clients. It does keep my overhead costs lower, which I can consider when billing.

3. What do you think is most important when setting up a freelance studio?
Unless absolutely necessary, don't try to buy everything at once. Buy the best computer equipment that is suitable for you performance-wise for the funds you have available at the time. Try not to shortcut, but plan for major upgrades at a later time—they can get pretty expensive. As far as the space, I'd say make it as comfortable and appealing to you as possible. You'll be spending a lot of time there; might as well enjoy the environment as well as the

work! But don't go bankrupt just to have an overly impressive physical space and setup. A little creativity can create a great studio on a limited budget. It takes time to build a business. Improvements in this area will follow naturally.

4. Do you ever have clients or vendors come to your studio? If not, why? If so, how do you create a professional environment in your studio?

I rarely do. I usually meet with the client in his or her office. I have access to conference spaces when needed for vendors, or I'll go to their office as well. In rare cases a client will come to my studio, but, mainly because of its limited size, it's not my first choice for a meeting.

5. Provide a detailed list of all equipment that you have in your studio—not just the technical stuff, but desks, conference tables, phones, etc.

I have a desk with a drawing table setup. A light box. A Kodak Carrousel projector. All the usual "traditional" technical pens, paints, markers, tapes, paper pads, etc. I have an entire wall full of shelves with reference books. I have a file cabinet filled with my illustration reference picture file. I have carts and several stacked decorative crates on wheels, full of client files. Because all I can do in my studio is go up, all the walls have shelves to hold computer disks, CDs and art supplies. I use lots of boxes for filing. I have a fax machine that can also make simple cop-

ies and two phones (one portable), one phone line with call waiting and three-way calling. An answering machine. Three bulletin boards. Three halogen lamps as well as several incandescent lamps. I have a Power Computing Macintosh clone (my second setup in five years) with 180MHz, a 1.2 gig hard drive, 8× CD-ROM drive, all the standard programs (Quark, Photoshop, Illustrator, etc.), a 15" Sony monitor, laser printer, SyQuest drive, an extra 740MB hard drive, two Zip drives and a 14.4 modem (with AOL). The computer sits on a small oak table. I have a comfortable desk chair with casters. A wooden desk chair for a change of pace, a couch, rocking chair and coffee table. I've budgeted for a scanner and color printer to be added shortly. (Until then I continue to go to Kinko's or I rent time from another studio for use of these two items. I'd say they are a must for a studio setup).

6. How did you choose the equipment that you have in your studio?

Each item was added as needed. There is easy and quick access to shopping for supplies, furniture, etc., here in Manhattan. Specific furniture was chosen by whether it would fit in my studio space or not! Most of my computer equipment was purchased through mail-order catalogs, which allowed me to compare prices easily.

7. How did you buy the equipment in your studio?

My original computer setup was

purchased when prices were still pretty high compared to now. I used some money from a savings plan I had from my agency job. The externals were added as needed. I budgeted for some pieces and was offered a family loan for others. I've tried to avoid too many commercial loans. I prefer buying over leasing for my situation since I don't have a large setup. Leasing seems like a good option, though, if needed in the future.

8. How did you get the most for your money when you bought your equipment?

I did a lot of comparing, mostly through catalogs. I also spoke to friends and colleagues to gain a perspective on costs as well.

9. What is your opinion and advice on buying good used equipment?

I haven't really done that to date, but I think it's a good option if necessary. I'd prefer to buy new, but if I knew the person who was selling I'd be comfortable. Through local Mac user groups I've located highly recommended experts who for $25 or so will go with you to check out used equipment before purchasing. I've also known people who have bought refurbished equipment and have been very happy with the performance.

10. What are your thoughts about renting equipment?

Around here renting seems pretty expensive compared to long-term leasing. With current prices as low as they are these days, I wouldn't want to rent for a long time.

33

"Christmas Tree"

"Sheep"

"Angel"

"Squirrel and Birds"

If you don't pay it off within a year, they usually will automatically set you up on a five- or ten-year loan at 21 percent—worse than a credit card!

Same thing with the no-payment-for-a-year deals. These deals are made assuming that you will not have the money to pay for it when your year anniversary comes along. As a matter of fact, most consumers do not have the money then, and that is how the stores that offer these deals make money. Prove them wrong: Plan ahead and put enough cash back to at least pay for half and then finance the rest. If you have built up enough business over the year, you will probably qualify for a real equipment leasing agency or some type of banking service, which we'll discuss soon.

Another option is the infamous credit card. A lot of professional organizations in our industry, such as the American Advertising Federation and AIGA, offer special credit cards to their members with fairly decent interest rates. This will allow you to cut your best deal with a supplier or mail-order house and charge it. Then your monthly payments will be low enough so you can afford them.

Always try to add at least an extra $100/month to the interest charges on your credit card. This extra cash will go toward your principal amount and will allow you to pay off your credit card obligation sooner. Take a moment to do some calculations to decide how much extra you can pay, then make sure you discipline yourself to do so.

Pay Cash or Borrow?

If you're lucky enough to have a cash surplus, think twice about unloading it on equipment. You're probably better off leasing equipment and using the cash as collateral to borrow against. We'll review tax savings in the last chapter of this book, but you should know up front that any interest you pay on loans for equipment is tax deductible. If you buy your

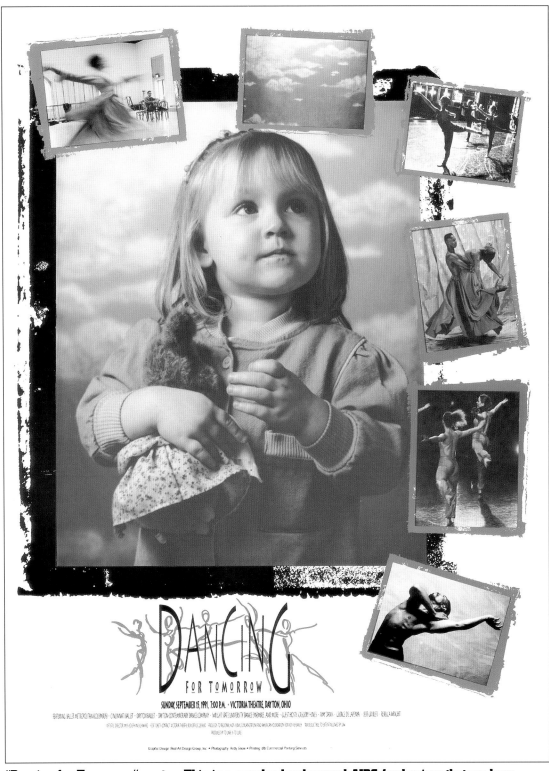

"Dancing for Tomorrow" poster. This is a popular local annual AIDS fund-raiser that we have supported every year since this first piece appeared in 1991.

equipment, an amount of the entire purchase price can be written off on taxes, and an entire lease payment can also be written off.

Before you decide whether to buy, lease or finance equipment, spend a little money ($40–$150) with a tax accountant who is familiar with freelance tax situations. Ask colleagues for referrals on who they use, and if you must use the yellow pages, ask for referrals and follow through on them. Have a tax accountant help you plan which option would make the most "tax efficient" sense for you. Refer to chapter nine for more details.

We'll also discuss more on establishing credit in chapter eight. Buying equipment with one of those extended payment deals I mentioned earlier is a good way to start developing a good credit history for yourself. Even if your credit has not been so great in the past, you will probably be able to qualify for one of these deals. Hopefully, you have been able to make other debt payments (car, credit cards, house, etc.) in a timely fashion throughout the past five years or so. If not, this may be a good time to "start over." Don't think that using a studio name instead of your personal name will make things easier. You will still be asked for your social security number and your personal signature as a guarantee that you will personally be responsible for the indebtedness.

If You Need More Options

If buying, leasing and paying cash are not options for you right now, there is still the option of renting equipment by the hour. For example, the Kinko's franchise leases some pretty nice equipment in this fashion. One of the biggest issues I have with this method is that you have to do your work on location. The good thing is that some places, such as Kinko's, are open twenty-four hours.

Many community colleges and universities offer student lab time during specified hours. Community colleges, in particular, generally offer state-of-the-art courses for nominal fees. A community college in my area currently charges about $30/credit hour plus a $45 lab fee per quarter. You can take a class (or audit one if you don't want the pressure of being tested or receiving a grade), learn some new techniques and have access to a computer lab for some fairly generous hours per week. Of course, I wouldn't make it widely known that you are supporting your freelance endeavors with college property—and I wouldn't take advantage of it forever either. I think it is, however, a very legitimate way to get started.

38

Chapter 3

How to Find Markets for Your Work

Something I share with students many times over, to the response of moans and groans, is that as designers we spend a good portion of our time on the job selling our work. Triple that time for freelancers. Selling can be a bad word to a lot of people. The word conjures up used car salesmen with bad toupees and raunchy automobiles. Here is where I point out that there actually are some great used car salesmen out there! In other words, selling can be not only fun but rewarding.

How to Find Business

The easiest way to sell is to network. This word used to be used relatively rarely and now we hear it all the time. It is becoming almost as overused and misunderstood as the words "value" and "quality" in the typical advertisement. Networking is simply a very effective, streetwise method for selling your services.

First, you make a list of everyone you know, down to your hairdresser and veterinarian. Next, you have some business cards printed (hopefully, they're creative!). When your cards are ready, either send letters to or personally contact everyone on your list. Give each contact a business card and brief description of the services you will be providing. Take the opportunity to ask as many of these people as possible if you can show them your portfolio, even if you don't think they could ever become clients—many of them will surprise you with the people they know and might be pleased to introduce you to.

Showing your portfolio to as many people as possible will raise your confidence level. You will be very accustomed to showing and explaining your work, and you can weed out your bad habits and poor descriptive phrases if you critique yourself after every review. Ask

your reviewer to be honest with you and give you feedback on your presentation. Offer to take a really helpful reviewer to lunch, or call in a couple of weeks and offer to have lunch or dinner together. Building honest relationships will improve your self-esteem and your integrity to others.

Developing good personal relationships will be very helpful in obtaining work later. The entire process becomes residually beneficial, and you will make some sincere friends along the way. As you show your portfolio, ask reviewers who they might know who might use your services. I have never met anyone who did not have a referral for me after seeing my work.

Join the Club

There are many opportunities to build great business relationships by becoming involved in clubs or associations that not only pertain to your business, but also your personal interests. First, joining your local AIGA chapter or advertising club will keep you up-to-date on local and regional awards competitions and other happenings in the creative industry.

Second, freelance illustrators and designers do indeed find business opportunities by attending these meetings. Take plenty of business cards along, and don't be afraid to introduce yourself and talk about what you do. Make sure you get business cards from the people you talk to and follow through with them within a week or so. That way they won't forget who you are. Be friendly but not pushy—remember the used car salespeople everyone runs from! Be yourself.

Your local chamber of commerce is an excellent source for meeting professionals who might be interested in your services. Call your chamber right now and ask for a membership package. If you live in a small town, the opportunities might be different. Your chamber may be in great need of better brochures or marketing materials, and you can help!

Joining a chamber in a bigger city and attending their networking sessions or seminars will be very helpful in introducing you to people outside the creative industries. You will meet people managing or owning industrial companies, retail operations, restaurants, etc. This is a great vehicle for you to meet prospective clients. If you end up meeting the owner of a company (which is not unusual at these events), ask who is responsible for their marketing or advertising, then ask if you can use his or her name as a referral to introduce yourself to that person. Again, I have never had anyone tell me no.

Doing Work for Free

What? Free? Our industry calls this "pro bono." Let me start by saying that many larger design firms and ad agencies frown greatly on this procedure. But let me quickly add that most of us provide these services on occasion. Respectable pro bono projects are most commonly requested by nonprofit organizations. There are many good, honest nonprofit organizations that do not have marketing budgets and, therefore, rely on the generosity of artists, paper companies, printers and the media to promote their needs. These organizations range from local children's hospitals and homeless shelters to the local ballet or symphony to larger associations like United Way or the American Red Cross.

Pro bono projects can and should be fun to work on. Generally, since your client has no budget, you are awarded the luxury of creative freedom. It is your responsibility to work with

the client and their other pro bono vendors to determine parameters and specs, but then you should be able to do your own thing. These projects usually become excellent portfolio pieces and award winners.

People working on marketing committees for the more prominent nonprofit associations are usually local philanthropists who hold key positions in the community. Many of them are CEOs of local companies or are actively involved in a number of community roles. These people know everyone! They will be wonderful advocates for you if you do a good job.

So, you see, giving your work away can certainly pay off in the long run. Especially when starting in your freelance career, it is beneficial for you to contact at least one of these organizations that is near and dear to your heart—one that you can personally relate to and, therefore, provide good services to. You will find great satisfaction out of helping an organization that needs your services and respects the talent you are offering. And, you will benefit by meeting many people who might use your services in a professional, profitable capacity.

Finding the Right Freelance Niche

It is certainly smart for you to develop a specific niche for your freelance services early in your freelance career. This niche should be one that fits you personally and psychologically. Some examples are providing freelance services specifically to ad agencies, design firms, industrial clients or corporations. The corporations list can be tailored down to retail organizations,

insurance companies, financial institutions, service organizations—the list is endless.

Establishing a specialty area to concentrate on will give you personal focus and help you build integrity within that classification of clients. Starting with a niche lets you work within the comfort level of what you know. After obtaining a comfort level within your niche, feel free to branch out and try others.

My father was a builder, specifically a custom cabinet designer and producer. Many times his tasks included working on entire rooms and houses. From a very young age, I learned a lot about building homes and about different wood varieties and grades. Therefore, when I started my freelance business it was a natural for me to call on builders, hardware stores and suppliers whose jargon I was comfortable with. The downside to working with this group of professionals was that they knew absolutely nothing about the value of a good logo or what they should pay for marketing services. We all learned a lot from this.

It will be natural for you to begin with the categories of business that you have some familiarity with. Through this process and belonging to organizations, you will come across a larger variety of situations and clients that you might grow into servicing.

Five Questions to Help You Find Your Niche

1. What were your parents' professions?
2. What are the professions of your aunts, uncles, those close to you?
3. What was your very first job?
4. What are your favorite hobbies?
5. What kind of communication issues did you grow up with?

Planet Fez Productions
On Being a Freelancer

Debra Matlock and Brad Grossman met at UCLA and formed Planet Fez Productions, an all-purpose digital video and graphic design company, several years ago. Debra won the Jim Morrison Film Award in 1991 for a student film about lobsters. Brad spent hundreds of hours with the family video camera and fulfilled his grandmother's astrological prediction that, yes, despite his parents' hope for a career in medicine, the stars paved the way for film school instead. Planet Fez currently creates the graphics for the Paramount television series *Sightings*, in addition to coloring books, band flyers and web site design.

1. What kind of networking do you do to meet new people and, thus, clients?
Quite frankly, we've been very lucky. All of our work has come from people we already knew or friends of friends. I think if you show that you can do a visually exciting, cost-effective, professional job, the word gets around.

2. Do you market yourselves as a freelance studio, or as individual artists who work together to comprise Planet Fez? Please elaborate.
To the outside world, we're a studio. Depending on the needs of the project, we may go to an artist who is a specialist in that particular area. Many of our friends are artists, writers, filmmakers and musicians, so

we've got a talent pool to draw upon. We also have a sister company (called Sub Zero) in Melbourne, Australia, that we work with closely. So we've got each hemisphere covered!

3. Why did you come up with a studio name instead of using your own names?
We thought that Planet Fez conjured up more about our style (futuristic, kitschy, kind of a neo-retro space vibe) than our individual names would. Also we work as a team. We're good at different things, so when you get a project completed by us, it's a collaborative effort. In our case, it suits us.

4. Do you do pro bono work? How do you think doing pro bono work helps or hinders in

finding markets for your work?
There is only one good reason you should do pro bono work, and that is because you will learn something new from the project. If you're just doing it as a favor, it should look good on a resume and/or demo reel. Or, if it's a web site, take a percentage of sales. Also insist on greater, if not total, creative latitude.

5. Have you ever turned a pro bono job into paying work? Please elaborate.
I wouldn't say a particular job "turned into" paying work, but it has *led* to paying work. For our biggest client, we will do tiny jobs for no additional charge. Also, we'll do low-res demos so a potential client can

get a good idea of what we could do, without being able to steal images directly.

6. What is your specialty? How did you decide it was your specialty?

We both were schooled in film-making but grew up with computers, so the multimedia/digital video field was a natural place for us to flourish. Then within that discipline, one of us is better at 3-D modeling and the more technical aspects of computers, and the other is better at aesthetics and Photoshop. Our individual specialties blend to form a greater whole.

7. Do you have a self-promotional brochure? What are the pros and cons of having one?

We actually got our first job without a demo reel or brochure, just an example of what we could do for them specifically. However, I think a bad brochure is worse than no brochure. Remember that you *are* a graphic designer; this brochure exemplifies what you are supposed to be good at. If you can't do a spectacular job for your own company, you certainly can't do one for a client's company. Also remember, most people don't have the vision that you have and will take whatever is in print as the absolute limit and style of what you can do.

8. Describe the primary ways you market your work.

Since most of the things we do are for broadcast, it's easy for us to tell someone to watch a particular show or go to a web site

to see an example. I think we may do a poster and/or post-card mailing for the new year. We just did a T-shirt for a band, so we may do a client gift Planet Fez T-shirt. You just have to decide whether the expenditure of money will get you any work, or whether it's just a gift to give out to your relatives.

9. Are you procrastinators when it comes to marketing yourselves? How do you deal with that, or give advice of how not to.

Remember there are thousands of people right behind you who won't procrastinate when it comes to marketing themselves. You just have to bite the bullet and get out there. Nobody's going to do it for you. You have to position yourself in the right place at the right time. It's all about luck and then the talent to back it up.

10. How do you motivate yourselves to get out there and market your work?

Self-motivation is the strongest form. If you love your work, you'll be motivated to do more.

11. How do you follow through once you have found a possible source for work?

Don't rest on your laurels. Keep in close contact with the potential client (without pestering them), but keep finding new work. Most often the project will change or fall through. So keep the momentum going, eventually one project will reveal itself as your next job. Also, don't start any work without a purchase order.

12. What is your primary method for finding new markets for your work?

There are design compilation books that feature work from different studios around the world on a specific topic (e.g., T-shirts, postcards, flyers). We've been in a few of these. It gives you worldwide exposure, as a web site would, to get your name out there. Primarily, we just try to meet as many interesting people as we can and keep on sterling terms with the clients we'd want to work for again.

43

Richard Rice

Assemblage

Planet Fez 3-D logo

Planet Fez business cards

Backwash logo

You will be surprised at how many fields you have expertise in, even if your job experiences were baby-sitting or mowing the grass. There are day care centers aplenty these days and countless lawn services—big and small—so go for it!

Question five will help you determine possible strengths and weaknesses that need to be built upon. Be honest with yourself. If you lived in a family in which conflicts of any kind were strictly off-limits, you may have a tendency to be weak in your negotiations skills. On the other hand, if conflicts were an everyday occurrence for you, you may need to be careful about when and how to defend yourself with your clients.

Avoiding Hang-Ups

What's a hang-up? Procrastinating, for one. You may have seen the skit on television in which a guy, Stephen Banks, is given a week to produce an important project for his boss. He spends most of the week going on dates, playing the guitar and watching TV. The skit becomes more and more hilarious as it progresses to the night before the project is due, with Stephen in his pj's making calls, still playing the guitar and doing everything *but* what he is supposed to be doing. The ultimate procrastinator ultimately gets himself into huge trouble.

Not me, you say. I always do things last minute. I do my best work under pressure. I always make my deadlines. I have had a plethora of students and employees lay these lines on me, and I can truly hear myself saying the same things to my superiors in days past. Older, wiser and grayer, I must admit that even I was wrong, although as I changed my process from senior procrastinator to occasional procrastinator, I did not even realize it was hap-

pening. Now, as I find myself arguing with others to change their ways, I know it is something that probably has to happen to most people in their own time. Years of observation prove that a change for the better indeed happens to most of us!

Building Self-Confidence

With accomplishment, self-confidence quickly follows. Many freelancers show signs of lack of self-confidence and self-esteem. I have learned that most of the time these freelancers are procrastinators and have not developed the omnipotent self-discipline discussed in chapter one. There is nothing more freeing than knowing you are current on your personal and professional obligations. Being bogged down with responsibility and being behind the eight ball is very wearisome and depressing, which breeds lack of confidence. Get over it! Begin my five-tip program on page 52 for immediate, positive results.

Do you hate making phone calls? Or do you enjoy it so much that you spend too much time on the phone? For those of you who deplore the telephone, let me remind you that until everyone is up and running with e-mail—which will probably happen five to ten years from now—the telephone is *the* tool for communication and obtaining freelance work.

Many of us don't realize that we have "call reluctance." When you find yourself dreading to make phone calls, get a grip. Most of the time it is a lack of self-confidence again that is getting you down. Your perception might

"Art That Works" poster. This pro bono project turned into an event at the Dayton Art Institute with the highest ever opening-night-party attendance at that time. We not only met a lot of potential clients at opening night, we had a lot of fun helping to put a show of this caliber together.

be (without even realizing it) that the person on the other end of the phone knows more about the subject matter you need to discuss than you do. My answer to that is, so what. Maybe you will learn something, and what is so bad about that?

Avoiding making telephone calls will result in immediate lack of productivity regarding creating new markets for yourself. Finding new opportunities requires you to have confidence and good telephone skills. If you know that this is a true area of weakness, contact Skill Paths Seminars [(800) 873-7545] or National Seminars [(800) 258-7246] for one-day seminar information on learning to communicate via telephone. These seminars are usually about $99 and include a money-back guarantee.

Following Through for Effectiveness

Proper follow-through requires focus and a certain element of procedure as you endeavor to find new markets for your work. Think of any times that younger peers have contacted you in a creative fashion that may have surprised you. Then hearken back to the days when you used to make special-occasion cards and notes for your loved ones. The appreciation and admiration you received in return probably kept you coming back with more.

Everyone likes to think they are special. Everyone likes attention. It is important as

Sheila Berigan
On Being a Freelancer

While Sheila Berigan was a student at the
University of Iowa, she applied for and got a
job as a keyliner, not knowing what the term even
meant. In her own words, "They quickly found out I couldn't keyline my
way out of a paper bag"; but they saw that she had design talent and kept
her on. After lengthy stints at two of Minneapolis's top advertising agencies,
Sheila left to become "the kind of mother and person I wanted to be."
Freelancing now for more than seven years, Sheila says it "has been the greatest
gift I have ever given myself." She works closely with freelance writer Shelley
Kingrey.

1. How do you find business for the most part? What kind of networking do you do?
We don't make that many business calls. Most of our business is done on referral. Shelley and I both were in agencies for ten to twelve years and managed to make a lot of really nice relationships in those agencies. We networked a lot, so when we did go freelance, people remembered us. It's been mostly networking and referrals from clients. We've been very fortunate that way. Also, since we do so much television, our work is seen by a lot of people. The clients that we work for on television don't usually have high budgets, but we try to give them a lot of bang for the buck. We offer the highest production values possible for their dollar. Most people can't afford to do television with an agency

because it's an extremely expensive proposition. Unless they get a little creative about how they spend their money, they can't afford to be on TV. Competition for the consumer is getting so fierce that clients find that if they're not on TV, they're not going to be able to compete. They want to make commercials as economically as possible, so they're turning to freelancers instead of agencies, which has been great for us.

2. Do you do pro bono work? How do you think pro bono work helps or hinders in finding markets for your work?
We do pro bono work from time to time, but we try not to pursue it. We have a lot clients, and we don't have much extra time. The only time we've done pro bono work is when existing clients get involved in a charity

and ask us to donate some of our time and talent. We're happy to do it. I think it helps us find new markets, especially if we did a print campaign or TV campaign and it's wonderful. It's going to help us by leaving a nice piece for our reel or portfolio—and a lot of people are going to see it. It's more of a time issue, not a money issue. Shelley and I both have young kids. In my case I'm a single parent. If I have free time, I want to do what I want to do. I want to spend time with my children or doing the other part of my life. My free time means a lot to me and I want to use it with my children—not working my life away.

3. What is your specialty? How did you decide that was your specialty?
If I had a preference it would be

to do television. When I began freelancing, I never dreamed I'd be doing this much television. Eighty percent of our business is television, and I think it's because competition for the consumer is so fierce. Newspaper readership is down, and in this town newspaper advertising is very expensive—it's outrageous! People are finding that they can be on the air and get more impressions than they can by putting an ad in the newspaper. Our clients are wanting to do more and more television, and it's working for them. They get immediate results, and they're almost afraid not to do TV. I went from print to television mainly because our clients grew. Gabbert's Furniture Stores were doing print exclusively before they hired a marketing research firm who told them they should consider TV advertising. They were very timid at first about branching out into television, and it took us probably a year to talk them into it. TV spots were a very scary proposition because Gabbert's didn't know anything about this medium and were used to their weekly print ads highlighting their sales and promotions. We did our first TV campaign for them four years ago, and the response was overwhelming. The amount of charge account customers was up, merchandise was flying out of the store and people were commenting on the TV spot. Every year we do a new TV campaign, and now they're afraid not to do TV.

4. Describe the primary way or ways in which you market your work.

We usually show a television reel, and, yes, we do have a portfolio. We used to lug around a really big portfolio, but it received too much wear and tear and wasn't looking fresh. We had it sized down to a smaller version, and it makes a nicer presentation. Paring it down made it easier to take around, and it's more convenient to ship, if necessary. If we have a brochure that we want to show off, we'll stick it in the back. What we are really trying to show is ideas and concepts. Hopefully, the visuals speak for themselves. We want to show people that we know how to think, we understand marketing and we want to work with them. We feel that the presentation has to be visually stunning, but we want prospective clients to know we do more than make pretty pictures.

5. Are you a procrastinator when it comes to marketing yourself?

Money is an issue and the greatest motivator of all when it comes to working and marketing your work. Two young children and a lot of bills can make you want to get out there and work your butt off. That helps to curb the urge to procrastinate.

6. How do you follow through on a potential client once you have found a possible source for your work?

Here's an example: The parent company for a group of malls that we work with from time to time really liked a campaign that we did for one of their malls. A marketing person from one of these malls said that her mall could really use a

strong campaign like the original mall had. The parent company didn't want to tell the person in charge of the mall that they had to use us. They wanted them to fall in love with us on their own. We ended up sending them our reel. And to follow up on that, we also sent a fun little thing—a hat. We schmoozed her, she appreciated it, and so now we're going to be working with her. So from time to time—for the business—we do this sort of thing. We don't want to spend a lot of money on self-promotions, so we follow up on leads and referrals as quickly as possible. If the potential client is in town, we try to meet them and show them our reel in person. We like to see their reaction.

49

"Father and Son"
30 second spot
(copy for commercial)

(Commercial opens with father and son sitting at the breakfast table. Scene is intercut with shots of casual dining sets.)

1) BOY: Dad, why do parents always say "we'll see"?
(Cut to studio shot of dining set)

2) ANNCR: At Gabberts we know the best times often happen around the table.

3) DAD: Oh, parents say we'll see when they want to think about it, son.
(Cut to studio shot of dining set)

4) ANNCR: And at Gabberts we have the tables and chairs people like to gather around.

5) BOY: I think they say it when they don't want to say "no" right away.
(Cut to studio shot of dining set)

6) ANNCR: Hundreds of casual dining sets guarantees there isn't a family we can't bring to the table.
(Mom walks in the kitchen.)

7) MOM: Honey, are you going to get the basement cleaned today?
DAD: Uhhh...we'll see.

8) *(Cut to boy giving Dad a knowing look.)*

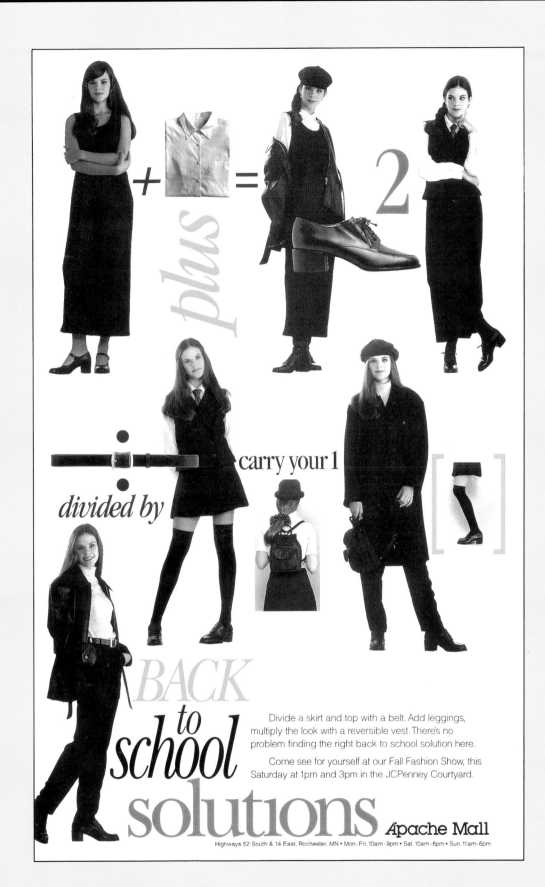

Divide a skirt and top with a belt. Add leggings, multiply the look with a reversible vest. There's no problem finding the right back to school solution here.

Come see for yourself at our Fall Fashion Show, this Saturday at 1pm and 3pm in the JCPenney Courtyard.

BACK *to* *school* **solutions** **Apache Mall**

Highways 52 South & 14 East, Rochester, MN • Mon.-Fri. 10am-9pm • Sat. 10am-8pm • Sun. 11am-6pm

FIVE TIPS FOR AVOIDING PROCRASTINATION

1. Go through your mail daily and sort things that need immediate attention—bills to be paid, items that need your return correspondence and material that needs to be reviewed more intensely (such as trade magazines). Throw away all junk mail immediately. Don't save it to review later because you never will—it's junk. If you are interested in any direct mail pieces, respond to them right then and there. Put bills away in a file to be paid this month or next. Give yourself twenty-four hours to handle return correspondence. If you let it go more than one day it will pile up so heavily that you will either never get to it, or by the time you do the people on the other end will have forgotten what it regards. Trade magazines should be put in a basket or file to be read within a week. Go through this basket weekly and purge items more than a month old. If you are going to keep them for creative reference, file them by month on a bookshelf.

2. Attend a professional association meeting or networking session at least twice a month. Follow through within one week with the people you met who might be future clients or good leads.

3. Do proposals promptly. If someone gives you an opportunity to quote on a project, respond within twenty-four hours. This will show them how interested and timely you are. If you wait longer, too many other things will pile up and it will be difficult to make it a priority. It also will not be as fresh in your mind.

4. Establish a schedule for a project together with a client when you bring a project in. Define your responsibilities as well as your client's. These commitments will act as your disciplinary measure.

5. Don't put off today what you think you might do tomorrow. Tomorrow will bring other opportunities, and you don't want to find yourself in such a spiraling vortex of opportunities that you end up accomplishing nothing.

Accomplishment is the key word to avoiding procrastination. Even something as simple as going through your mail can bog you down with things to do, and not putting a specific schedule to bringing these things full circle will result in certain procrastination. We all think we can supersede this bug and rise above it. It will take only one deadline missed and one disappointed client for you to change your ways. Making a commitment to these five tips will at least keep your daily tasks and issues current so if a tight deadline does occur, you can more effectively concentrate on it.

you are developing rapport, and even after you have repeat business, to develop a method for following through with the client that works for both of you. Follow-through can take a number of forms. Committing to developing the right follow-through for your business is key to your future success. I tell my staff all the time, it is one thing to obtain great work and clients—it is another thing to keep them.

The World Wide Web

I asked all the freelancers interviewed for this book their opinions about using the World Wide Web for marketing their work. I got different answers from everyone, but one theme rang true. If you are not a technical freelancer—that is, if you yourself do not use the computer to produce your services—having a web site probably will not complement your marketing effort. However, one illustrator commented that his agent had a web site showing small portfolios of his artists' work; in his case, the right art director happened upon it, and a two-year project resulted.

What the results of my informal survey also proved is that the Web is simply another vehicle to use for marketing. It works for some people and not for others. Like any other form of "cold" marketing, it is an introduction of your services to parties unknown to you. The great thing about the Web is that others can access your site using key words; such as

illustrators and *graphic designers*. It is a visual yellow pages of sorts.

If you decide to design your own web site, or offer your services on the Web, you will probably be best served by a local provider. Check for these providers through your local chamber of commerce or advertising association (networking, remember?). Check their referrals and Better Business Bureau standing. Ask to see examples of web sites they have created. The functionality of your web site must be programmed in the HTML computer language. Unless you are a very technical person, you will probably need someone to do this for you.

Do you really need a web site? The answer lies only within you. I don't have an ad for my firm in the yellow pages, and we are only in the beginning stages of assessing whether we will do a web site. If we decide to do one, it will be only so clients can see our technical capabilities and the skills of our many different staff members. As a freelancer, your answer should lie in what types of clients you have and what you desire your image to be. If you do a significant amount of work for

Art & Culture...

It's more than a

Saturday Night!

WORKS CULTURE!

It's everyday

for everyone!

CALL 222-ARTS

Design: Real Art Design Group Printing: Patented Printing Paper: Frazier Paper

Culture Works is a regional nonprofit organization that we have supported with pro bono work. It helps fund more than four hundred arts and cultural groups in our area. Some very influential professionals sit on the Culture Works Board of Directors, which has been great for networking and also for keeping our firm's name fresh for the regional arts groups.

out-of-state and/or high-tech clients, having a web site is an excellent way to share your skills long distance.

Committing to a web site is not very expensive and is getting cheaper all the time. The provider you choose might do your HTML programming and then charge you a monthly maintenance fee, which will keep your site up and running. You decide how often you want this site to change. If you want to add or delete items, you will be charged a fee each time a change is made.

An ever-increasing number of seminars and trade shows are geared toward marketing on the Web and designing sites. If you are confused about which way to go, attend one of these seminars. Many chamber of commerce groups have members who specialize in these services and offer seminars or consultations for free.

Chapter 4

How to Promote Yourself

The identity and image of your freelance business are immediately perceived by others via the look of your business cards, letterhead and mailing envelopes. Your business cards should represent your professional style and perhaps say something about you personally. Color, texture, design, typeface, etc., will be interpreted by the recipient. Creating this new image for yourself with you as your own client isn't the easiest of assignments.

Creating the Right Identity System

Treat this project of creating an identity system for yourself as you would a paying job. Give yourself a deadline. Do several rough concepts before you decide on the final selection. Use other design colleagues, friends and family to see what their perceptions and opinions are. Ultimately, go with your gut feeling on which one best portrays your professional acumen.

Establishing a budget for your own identity needs is not a simple task either. Suddenly, you're spending your own money instead of a client's. Now you know how they feel, right? You are aware, of course, that you can get a two-color piece printed for nearly the same dollars as a one-color piece, since it will proba-

bly print on a two-color press anyway. Jumping to three or four colors will bump you up to a four-color press.

I encourage you to come up with a design you are very happy with before you decide on a final production budget. After you are pleased with the general direction, begin looking at paper and finish options. As you know, paper and finish selection are integral to good, finished design. Will you use an emboss, a foil stamp, a metallic ink, varnish? Any number of techniques, such as die cutting or folding, may cost extra.

If your design is exceptional, the regional paper representative from the paper company you choose may be interested in printing some extras for his own sales distribution to show off your particular production technique or design on his paper. This might lower the cost per unit for you. If a paper company is really

taken by your design and accompanying techniques, it may decide to give you the paper you will need for your own press run. While you cannot count on this happening—paper companies are deluged with such requests—it does indeed happen on occasion, and you have nothing to lose for asking.

My biggest advice to you during this entire design and production process is that you do not skimp. You are creating an identity that will obtain good-paying, profitable projects for you. You are embarking on a professional career that many people will be envious of. Everyone is not as strong as you are to take the risk of leaving a "real job" to freely go where only entrepreneurs go. Many people will look up to you and look to you as an example of the free spirit hidden in themselves. Do not disappoint them or yourself.

Know the Differences Within the Creative Industry

Educate yourself first and your clients second (if necessary) about the precise differences among advertising agencies, design firms, marketing consultants, public relations firms and freelancers. Many times these five professional establishments are convoluted into one big melting pot, and I have been surprised at different stages in my career by how many people simply do not know that there are distinct differences among them.

Advertising Agencies

A very large advertising agency might include a graphic design division, a marketing specialty group and a public relations department. Sometimes all of these agency departments are housed under one roof. Many times these services are provided to the agency via separate entities that work solely for, and often are owned by, an agency. Thus, I believe, the confusion.

An advertising agency creates advertising campaigns and sales collateral not only for retail/consumer end use, but also for business-to-business use. An agency buys and places media. Placing media means such things as buying magazine advertising space, newspaper advertising space, radio/TV air time for commercials, billboard locations, etc. Advertising agencies bill their clients not only for their creative work, but also for the media buys for which they are responsible. This is why you read about large agencies billing out billions of dollars per year. Agencies normally provide a comprehensive advertising plan for their clients, from initial concept to developing a budget for the client to spend on various forms of media.

Design Firms

A design firm's major responsibilities include the actual graphic design of end-user pieces, be they consumer or business oriented. A design firm does not buy or place media. Many times a design firm works within the comprehensive plan created by a client's advertising agency. Design firms are most commonly credited with the creation of highly focused visual communications pieces—annual reports, capabilities brochures, corporate identity, etc.

57

Marketing Consultants

Marketing consultants provide strategic marketing planning to their clients. They gather data via focus groups, customer spotting or other forms of research. Once specific data is gathered, it is put into a format that will help the client arrive at specific objectives that the consultant is given. Objectives may be to increase sales within a certain target audience or to bring higher student enrollment to a college. Many advertising agencies provide marketing consulting services.

Public Relations Firms

Public relations firms do not buy or place media. Very seldom do they even staff graphic designers who produce the actual creative product for their clients. The objective of a public relations firm is to either create, maintain, improve or perfect the image of their clients to the outside world. The outside world could be consumers like you and me or other corporations, depending on the client's line of business. Public relations firms write speeches for CEOs, help a company prepare to speak with the media during trying times, help promote a client's new product or services by announcing them to the press and coordinate events that ultimately build the client's image and integrity of their clients.

Freelancers

Freelancers most commonly work from home; sometimes they have separate studios with unique names and addresses (such as Planet Fez Productions, interviewed in chapter three). Freelancers are subcontracted by advertising agencies, design firms and small and large corporations to provide a variety of design, art direction, copy or illustration services. A freelancer's client is most often an art director or a director/manager of marketing.

Advertising agencies, graphic design firms, marketing consultants and public relations

firms are all excellent clients for freelancers. It is important for you to know the role you will be expected to play within any of these organizations: Will you have direct contact with the client or the employees of the agency or client?

Promoting Yourself for the Long Term

It's so easy these days to get caught up in trends. We as designers are a fairly fickle crew by nature. One month it's hot pink, the next it's nature colors. The point I am making is that while designers are usually the responsible parties who first design and then follow trends, you will need to take a look at the bigger picture when designing the image with which you will promote your services.

This means staying away from issues that might offend some people. As I am writing this book, the grunge look is in. Tattoos are hot and so is body piercing. By the time this book is published something else will probably rise above these trends. Therefore, it would be foolish for a freelancer in my market who has great aspirations to provide creative services to the Mead Corporation (a conservative Fortune 500 company with headquarters in Dayton, Ohio), to market himself as a tattoo artist. Get my drift?

It would also be foolish for this freelancer to appear in front of the marketing director for Mead Paper Products with a pierced tongue. This book is about streetwise advice, and that's what I'm giving you. I'm not saying you should pre-

tend to be someone you are not. I'm saying that you should be smart about who you are.

Persistence vs. Annoyance

Another tip in promoting yourself for the long term revolves around being persistent without getting on your clients' nerves. We all know someone who telephones us just a little too often, and once they do get us on the phone, talk just a little bit too long. On the other hand, we know people we hear from often, but not too often, with a welcoming ear.

The way to be a person who is welcomed (for the most part) by your client or potential client base is to let your clients decide your method of persistence. I touched a bit on this in chapter three, but it is worth repeating here.

Learn to Read Your Client

First and foremost, if the person I am meeting with seems rushed or not interested, I offer to postpone the meeting to another day that might be better. Just offering this option sends most people into a more relaxed attitude toward you. Yes, you may have been dying for that appointment, but if you offer it to be resched-uled, your information will be better received and focused upon. The person will feel some-what indebted to you, and you will be in more control of the situation. Most of the time, the person will go ahead and meet. Make the meeting shorter than usual, acknowledging their needs and being certain they know that you understand.

Every time I meet new prospective clients, I stop after my portfolio review and listen for their initial response. Their feedback usually tells me what types of projects they give out; if they don't offer this information, I ask for

59

We don't have titles at Real Art, so our business card and corporate identity system feature a different visual identity that connotes each person's work task and personal attachment to the firm. My business card has an eyeglasses icon because I have the "vision" for the growth of the firm—and I have an extensive eyewear collection! My partner, Chris Wire, is our creative director/big-idea man, thus the electrical outlet, also matching his last name. Betsy is a worker bee and we call her "B." The megaphone on our presentation flap sticker illustrates the function of the piece itself, namely, a cheer or announcement.

it. Then, I ask them how they prefer me to stay in contact with them since, very rarely, do I get handed a project on the spot (It does happen sometimes!).

A lot of people are surprised that I ask *them* how I should stay in touch. I tell them that I myself am frustrated by vendors who call too often or stop in without an appointment. Then they answer me and I take notes in my day planner before handing them my

business card and asking for theirs. I always make it a point to follow up in the manner they prefer—e-mail, phone calls, packages with samples, etc. Immediately, I gain trust and build integrity and sincerity. Work comes sooner than it did before I began this practice.

These two tips—recognizing your prospective client's time needs and asking about follow through—will practically guarantee

that you will never get on your client's nerves. These practices also show persistence and tenacity, which are valued in our industry.

The Importance of Selling

It's really too bad that no college or design school visual communications curriculum requires concentrated classes on salesmanship. (At least I don't know of any—write me if you know of one.) No one told me while I was toiling away at design theory and technique that if I didn't know how to sell I would not succeed in the creative industry. Even when you have a full-time job at a firm or agency, you have to "sell" your concepts to the art director, account rep or client. The pressure to sell your ideas is unbearable sometimes, especially when you know you have a good idea and no one is buying it.

Throughout this book I go back to issues that evolve to or from the art of selling. Organizational skills, planning, scheduling, setting up your studio, finding a niche for yourself, following through—all of these issues revolve around your method of selling your services, your image, your particular style or your niche. The relief I can share with you is that you can absolutely be a successful salesperson without being stereotypical. I have shared many of these successful tips, but I think it is important to categorize them for you so you will see that they truly are methods of selling.

Sales Techniques

First of all, don't be timid about introducing yourself. Offer to join work committees for your local ad club, AIGA or equivalent. Don't be shy about getting your name out there. Joining committees whose objectives you might share will result in your name being given to others and being announced at certain events. Volunteering will involve you at some levels of group participation that will help you develop all kinds of street smart skills necessary for success. Pick any topic in this book that I discuss as a necessary skill for you to know; being an active committee member will help you hone that expertise.

Then there is that organization/self-discipline thing. Being organized will afford you more time to be involved. A good calendar will keep you on time (you never want clients waiting for you to show up). Self-confidence will help your sales meetings reach supersonic heights. Following through in the manner that your client asks you to will impress him or her and be more effective for you—because you are doing it the client's way, not yours.

I mentioned earlier that I give my business cards after my portfolio review. I feel very strongly about this procedure—even if a prospective client hands me a card as soon as we meet. As I show projects and talk about my work, I am usually able to develop rapport with people. This is a great feeling, and I am then challenged to involve them, to say something that will make them laugh or respond in some way to my work.

It seems that through this process and after reviewing the portfolio work, I have my prospective client's respect—both as an artist and as a peer. I then feel very comfortable presenting them my card, knowing that this person is

interested in my work; perhaps we have already discussed upcoming projects where we might have a fit. Sharing my business card brings a good time to discuss follow-through and specifics on those possible projects. It is simply a friendlier time to distribute your "commercial" information.

Ugh! Public Speaking

Speaking in public is also a fine way to sell your services. I don't suggest this sales technique for the squeamish or socially introverted types—not at first, anyway. Many organizations look for experts of all types to speak on many different subjects. You might talk about good design for direct-mail pieces to a direct-marketing organization; or an illustrator might talk to an advertising association group about a technique he developed for a popular advertising campaign and what made it successful. Even sharing your knowledge with college students at portfolio forums might residually bring you work and contacts. Students go out into the world and get real jobs at real companies who hire real freelancers!

If your public speaking technique finds you turning bright orange with heart-pumping anxiety or your voice trembling like Mt. Vesuvius overlooking Pompeii, take a speaking class immediately at your local community college. Get over it. Don't use the excuse that you're an artist and were not trained to speak in front of large groups. Taking a class will force you to learn and practice your public speaking. This is an invaluable tool that you must perfect to be effective, even in your own sales and project presentations.

Do You Need a Self-Promotion Piece?

When I started freelancing, many corporate marketing people and business owners asked me if I had a brochure. I was frustrated not to have one; it was virtually unaffordable. I was pretty much stuck into providing freelance production services at that time along with simple one- and two-color design applications. I was certain that a full-color brochure would attract the types of clients and projects I wanted.

A photographer friend and colleague offered his services pro bono if he could have some brochures to distribute as samples of his work. Then a printer offered to print the brochures at cost. I was doing some work for the Mead Corporation at the time, and they helped me with a paper donation. Color separations were negotiated at cost also, with notation of credits. This was 1985 and the piece still cost almost $6,000. I remember my husband joking that we could have bought a Yugo with the money. The ironic thing is that no one even knows what a Yugo is today, and the money spent on the brochure was the beginning of great promotion and image building for my business.

It was a scary time though. Spending that much money on something so speculative made me crazy. I kept telling myself that one or two good freelance projects would pay for it. The inevitable came true and it all worked out. The piece paid for itself immediately. Because my portfolio at that time did not reflect high-end art direction with photography and illustration, I made sure that the brochure

Josef Gast
On Being a Freelancer

Photo by: Lynette Johnson

Josef Gast studied graphic design and illustration at Ohio University in Athens, Ohio. Prior to becoming a freelance illustrator, Gast was an art director in educational publishing.

A regular contributor to *The Washington Post*, his other clients include American Express, AT&T, General Electric, United Parcel Service and *U.S. News & World Report*. Josef works out of his lakeside home in Seattle, Washington.

1. What advice can you give regarding creating an identity system?
Some illustrators spend a lot of time creating an identity—I spent about five minutes! Simply put, I wanted an identity that made it clear that I was a serious design professional. I asked a typesetter, Dawn Horn of Littleton 2, to put something together for me. She did a beautiful job. I never bothered printing letterhead, just shipping and flap labels for my artwork.

2. What is the primary method in which you promote yourself as a freelance illustrator? Do you have a self-promotional brochure?
Each year I purchase a page in the *American Showcase* and a spread in a promotional book my agent creates and distributes. Occasionally I'll put together a self-promotional brochure. Something simple with three to eight images seems to

work well for me—a mini-portfolio of sorts. I just want my promo to remind art directors that I exist and that I do excellent work.

3. Do you ever consider yourself a "salesperson"?
Sure, I'm a salesperson. Though my agent gets me the assignment, if I want a second or third assignment from the same source I do have to sell myself. I do that by contributing to the problem-solving process, articulating my (or the client's) ideas visually, keeping deadlines and creating a quality piece. Then, if I'm lucky, they'll call again.

4. Give us some tips on how you show your portfolio to prospective clients. What kind of portfolio do you have and why?
My agent keeps four or five book-type portfolios of my work at his office. If a potential

client is interested in seeing more of my work he (my agent) will send a portfolio to them. I make sure that my agent gets copies of current work so that my book is up-to-date, but I don't personally keep or present a portfolio.

5. How did you select your agent?
My agent is Scott Hull of Scott Hull Associates, Dayton, Ohio. When I began my career as a freelance illustrator, Scott was encouraging, but didn't take me on. When he thought I was ready, he asked if I wanted his firm to represent me. I jumped at the chance. Like many artists, I'm not especially outgoing. I wouldn't want to walk into a strange office and do a presentation. Scott and his staff will do that for me, plus they have the marketing expertise that I lack. I draw, they sell. As far as I'm concerned, it's the perfect marriage.

63

These illustrations were created for US West.

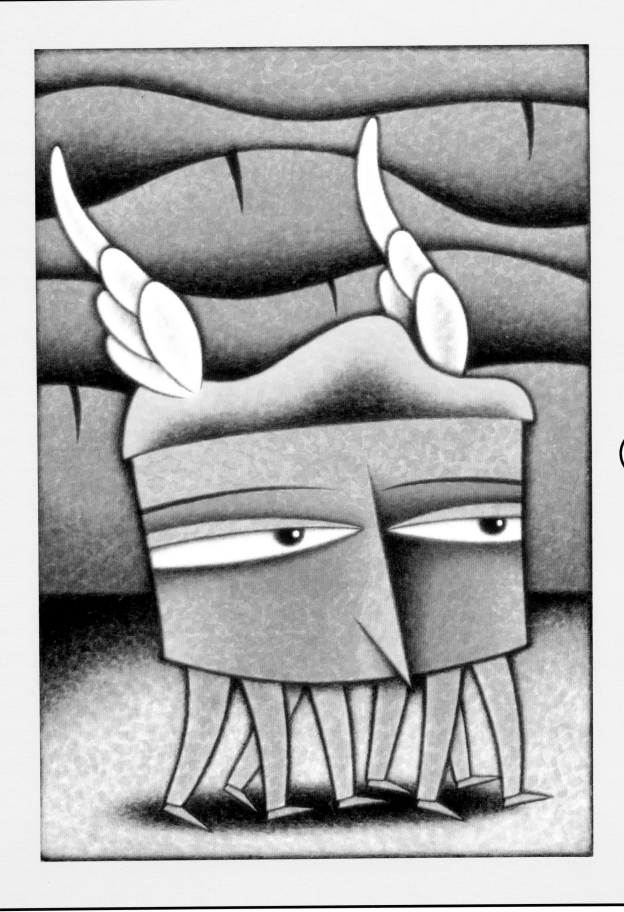

featured it all. It even landed me my first appearance in the *PRINT* magazine design annual.

My advice to freelancers today is to do brochures or self-promotion pieces if their portfolios truly do not reflect the range and quality of their skills. If your portfolio is strong and you are getting the types of projects that you want, there is no reason to do one.

My design firm does not have a current self-promo piece, nor is there one in the works. When someone asks if we have one, I send out our presentation/proposal folder with a cover letter, a history of the firm and some recent samples. Our folder is designed with a portfolio pocket to house the samples, with a nice embossed cover. It speaks for itself along with our entire identity system. Of course, having a $25,000 identity system is something that was not affordable at the freelancing outset.

Most of the freelancers interviewed for this book do not have specific self-promo pieces. You will find that most freelancers who do have a piece, however, designed and produced the piece around donations and cost negotiations as I did when I started out. Many paper companies are generous with donations when a piece is designed with unique production values that will help them sell paper.

How to Promote Yourself Effectively

If you are determined to do your own promotional piece, treat it as you did your identity system—like a paying job. Plan it carefully, and share it with colleagues—specifically, photographers, illustrators and printers. You might attempt to do a cooperative piece with several different sources. Many printers and other creative individuals are looking for ways to promote themselves, especially those people

new to your region. Don't be afraid to approach them; all they can do is say no. If you have a great theme and can readily explain how they might be included, that will certainly be an asset for you. It will not only be a relief to them, it will further show off your creative skills in the end piece.

Self-promo work can take many different formats. Especially with high-quality color copy capabilities and Indigo (a brand name for short-run, high-quality color printing found at some printers), designing pieces for your own marketing needs has never been more affordable. Think about doing pieces that could have multiple uses, such as a postcard series or a monthly calendar self-mailer on which you can use the back side to write personal notes of thanks or follow-through.

Competitions are another great source for self-promotion. Along with the top design annuals—*Communication Arts*, *PRINT* magazine, *HOW* magazine, *Graphis*—there are also many smaller but high-quality competitions held around the country. Most paper companies have ongoing awards programs on certain grades of paper. The Mead Corporation has the prestigious Top 60 Award given annually to the sixty best pieces printed on any Mead paper. Many local and regional advertising and design club associations have their own awards programs. Check with your local paper reps and creative associations for specifics.

Even if you don't win top billing, your goal should be to get your work shown in any of these competitions. Getting an honorable mention or certificate of merit or excellence is something to be very happy with. Announce your award winners via a special mailing—perhaps a mailing of the piece itself to your top-notch clients and to those clients whose attention you've been trying to garner.

If your work is chosen to appear in an annual or a magazine, pay for reprints or have high-quality color copies made and send them to your entire client and client wish list. Follow through with a phone call or e-mail in about a week to make certain it was received and also to discuss any upcoming projects you might assist with.

Remember, the true rewards in our industry come with clients who are so happy with your work that they keep coming back to you for more. Don't get obsessed with winning awards competitions, especially if you are maintaining a steady flow of projects, 50 percent of which you can really get excited about. Many of your projects won't be pieces that will be of award-entry quality anyway; they pay the bills. Every designer or illustrator, no matter how prestigious or well known, has gone through what you are going through.

The Ultimate Priority—Your Portfolio

OK, so you know how to get organized, introduce yourself, follow through, maintain self-esteem and find markets for your work. The ultimate test will be your face-to-face (or face-to-portfolio) meeting with a prospective client. Don't blow it with an inferior portfolio or, worse, a decent portfolio but an inferior presentation. If you are a great designer and wonder why you don't get work, it probably has to do with your portfolio or your presentation.

Let's talk about the actual portfolio itself. Is it beat up or scratched? Was it your student portfolio? Is it the big binder type with acetate pages? If you answered yes to any of these questions, it's time to invest in a new portfolio. I know, portfolios are not cheap. Ask for gift certificates from your favorite art supply store for your birthday if you have to; just do it.

Your professional freelancer's portfolio should be of the box variety. This suitcaselike portfolio style is the most professional style available on the market. Many custom portfolio houses are popping up that provide wonderful fabric or leather finishes. Look in the back of industry trade magazines for special advertisements and mail-order phone numbers. I recently had a beautiful black leather box made, extremely durable for traveling and very functional, for $600. Since it should last at least three or four years, that's just $125/year, and it will look great as it ages. Of course, there are excellent designs for less money; but remember, you do get what you pay for.

Portfolios of this variety require you to mount either a transparency format of your work into a matted window or the actual printed sample onto an illustration board of some variety. It is common for illustrators to have transparencies made, all 4×5s, and then mounted on an $8'' \times 10''$ mat. If your portfolio is of the transparency variety, have a small, high-quality light box either built into your portfolio or easily removable. Don't count on your prospective clients to have a cleared off light box to look at your work.

Designers should show the tactile quality of their work. Mounting actual samples on white or black illustration boards is highly acceptable. The downside of this style of portfolio is that the corners of your boards will get bonked every once in a while, and you will need to clean up your boards before every portfolio review.

67

I have a Macintosh PowerBook that allows me to play multimedia presentations in high-resolution format. I thought that once I acquired this wonderful tool I could kiss my portfolio good-bye forever. After several portfolio presentations on my computer, I realized this would probably never be the case. Since paper selection is so integral to the design process, the PowerBook just couldn't come close to having a hands-on portfolio. It is great, however, for showing multimedia CD-ROM samples or Web graphics.

Presenting Your Portfolio

Remember, presenting your portfolio is equally as important as how your portfolio looks. I think this is your biggest challenge. Your portfolio is a bulky, awkward, heavy monster (mine weighs twenty-five pounds on a good day). It gets caught in elevator doors, brushes expensive crystal off shelves in department store displays and leaves the hand you're using to carry it, cramped into a permanent "c" position. Parking any distance from your appointment requires a treacherous balancing act for winter walking or a sweaty, miserable walk in the summer, leaving you panting at your client's door.

The moral of this little story: Be prepared. Either valet park at every given opportunity or allow at least fifteen minutes extra time to compose yourself before your appointment. When you travel with your portfolio, either have a collapsible wheeled carrier or a personal butler carry it for you.

Once you get in the space where you'll be presenting, quickly scan the room to decide where to sit and how to unload your box. Small offices where you sit across the desk from your reviewer will probably require you to kneel down on the floor, unload your portfolio and set your stack of boards on your reviewer's desk. You will need to be comfortable talking about your work when viewing it upside down.

A big conference room is a luxury not often experienced. When you do get the opportunity to spread out, I still advise you empty the boards from your box and then proceed to either stand up and show your portfolio on an easel if one is available, pass the boards around if you are showing them to a large group, or simply place the boards one at a time in front of your reviewer. I like to stand and show my work because it helps me focus on my presentation. Eye contact is also important. If presenting to more than one person, make sure you give equal attention to each member of the group.

Know your reviewer. Will they be interested in technical production information? New paper applications? New software techniques? Some people couldn't care less, so use common sense when presenting. Pay attention to how your reviewer is responding to the information you are sharing.

Organize your portfolio by objective, i.e. corporate reports, identity pieces, direct-mail brochures, etc. Don't jump around from type to type. Always state the objective of the piece; show the before's and after's if possible.

Keep your presentation to no more than thirty minutes; twenty to twenty-five minutes is even better. When you are finished, ask your clients if they would like to see more of any particular type of work; more logos, brochures, etc. Take note of the response and follow

through appropriately. This is the time for you to ask the clients to show you some work they have done or other work that the company uses for promotion. Ask how often they redesign their brochure. This will open your door of opportunity to quote on the project when it arises again.

Keep It Scrupulously Clean

No one ever believes me at first when I tell them, usually as students, that they need to clean up their portfolio before every review. I could devote a book to the importance and how-to's of portfolio maintenance because I am so obsessive about it. You will find most creative and art directors to be obsessive about it also; indeed, I am not alone!

Keep a rubber cement pickup handy as well as rubber cement thinner, a KOH-I-NOOR yellow imbibed eraser and a Mars white eraser, and take a keen eye with you everywhere you go. Most commonly, you will show your work under a direct light of some type, either at a conference table or in someone's office with fluorescents streaming their telling shine over flaws you never imagined were there in the soft light of your home.

Be overly critical of any dirt, dust, fingerprints, hair or other pesky residue that seems to be attracted to your portfolio like flies to molasses. If someone close to you can look at your portfolio for you, that is even more helpful. Sometimes it is difficult, when you are so accustomed to looking at your own work, to see dirt or flaws. Most fingerprints will easily rub away with a rubber cement pickup. More stubborn spots will remove with either eraser variety mentioned above.

I have polled many portfolio reviewers for my students and readers throughout the years, and

we all agree: If you do not think enough about your own work to keep it clean in your presentation, then the work that you provide will probably reflect the same uncaring attitude. While this may not be true, please believe me, it is the most common perception of your onlookers.

Other things to look for in your portfolio are the bonked corners aforementioned. Take the time to remount your sample on a fresh board; bonks are not repairable. Make sure you get plenty of samples of your work so you can freshen up your portfolio often.

Use rubber cement (the two-coat variety) to mount portfolio samples. I know you are probably about ready to take this book of street smarts and throw it across the street, but trust me—rubber cement is best. It will not react to changes in temperature, it is the easiest glue to clean up, and it is usually easy to remove a sample with rubber cement thinner and use it again on a fresh board.

How Do You Know When You Need an Agent?

You need an agent when, for whatever reason, you cannot (or refuse to) sell. You need an agent when you cannot put food on your table. You need an agent when you have problems getting your invoices out. You need an agent when you have problems collecting money from clients in a timely fashion. You need an agent when you do not have the time or know-how to put good contracts or proposals together. You need an agent when you want to

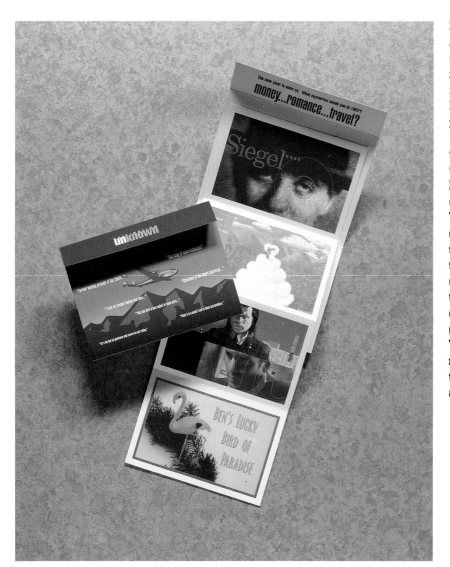

Every new year, Real Art sends out a card that has an interactive message for the recipients. Last year, every person on the staff (even the office manager!) designed a travel postcard hinting at the destination—Las Vegas. We asked everyone on our mailing list to guess the unknown destination and send the answer back to us on a card. Then we gave away a trip to Las Vegas by having a random drawing of the correctly answered cards.

do national or international work vs. regional. Get the picture?

Agents can be wonderful, like fairy god-mothers, or they can be your worst nightmare, collecting money for your work and then not paying you. Shopping for an agent can be a real challenge. First of all, obtaining an agent is a challenge to you as far as the quality of your work goes; turn the table around and ask yourself why an agent would want to represent you. What kind of money can an agent make

from you? Is your work unique? Do you deliver on time and on budget?

Freelance illustrators most commonly have agents. Freelance designers most commonly don't. Let's begin with some conversation for the illustrators. If an agent is interested in your work, consider yourself blessed. Beginning freelance illustrators usually will need to be published for quite a while before an agent will pick them up. Agents want their relationships to be long term, and if an illustrator can prove

PORTFOLIO DO'S AND DON'TS

Do

- Make sure you have a new-looking portfolio.
- Clean up your portfolio the day of every review.
- Treat your portfolio like your most prized possession.
- Mount your samples with rubber cement.
- Have at least twelve, but no more than sixteen samples in your portfolio.
- Place your portfolio in the front or back seat of your car, not in the trunk where it can slide around.

Don't

- Leave your portfolio in your trunk overnight.
- Eat, drink or let anyone else eat or drink anywhere close to your portfolio.
- Skimp on the overall look of your portfolio.
- Check it with your luggage while traveling. Request a special jetway check that will allow you to pick it up on the jetway after your flight.
- Let cats, dogs or other furry animals within ten feet of your portfolio.

his salability on his own, then all the better for the agent.

Agents for graphic designers are very high-end, and most of them are found in very large markets, specifically New York City. Since there are fewer agents for designers, your work must be the cream of the crop.

Very seldom will an agent contact you for your representation rights. If this happens, you are either extraordinarily talented, or the agent is probably not very reputable—perhaps just starting out himself. Most commonly, you will seek out an agent by studying publications like *American Showcase* or the *Graphic Artists Guild Directory of Illustration*. You will become familiar with agents' names and determine which agents might best be suited to representing your work. For example, if you are an airbrush artist specializing in an art deco style, you would not approach an agent who is already repping an artist with a similar style.

Contact the agent with a professionally executed cover letter along with several transparencies of your work. Make sure to enclose

a stamped, self-addressed envelope for their safe return. Follow through on your package within a week of the agent having received it. Use an overnight or two-day service to deliver your protected package. This will not only ensure that your package is not bent in transit, but it will get more immediate attention from the recipient.

Research your prospective agent a bit more thoroughly when you're just about ready to commit to him. Check him out through the Better Business Bureau, your local chamber of commerce and your favorite industry trade magazines. Ask more pertinent questions, such as how often marketing materials are generated, whether there are extra costs to you for the production of these materials, whether your agent pays for your appearance in any *Showcase*-type publications, etc.

Contracts with agents differ on such points as what you will do if someone contacts you directly for work, how often you will get paid and what percentage will go to your agent. All of these issues will be negotiated during the

71

initial agreement phase. You may want to sign a one-year contract rather than a multiple-year deal to see how things go for a while. You might have a third party (do you have any lawyer friends?) review your contract and explain it to you before you sign it, especially if your agent has drawn it up. Now is the time to ask every question you can think of and not be timid.

Agents take a percentage of the total dollar value of a project. That percentage can range anywhere from 15 to 30 percent, depending on the arrangement and service contract you have negotiated. Before committing to any particular agent, ask for referrals, not only from artists he may represent, but also from end-user clients. Critique the agent's marketing materials to be sure the image he portrays is one you can be comfortable with. Look at an agent as you would a marriage (really!). This person will be not only selling your work, but also negotiating the value of your work with clients, preparing usage rights and pricing, invoicing, collecting and paying you! It is important that you not only like this agent professionally, but also, personally, down to the clothes he wears and the way he shines his shoes.

It's Still Up to You

Even with an agent, the act of promoting and selling yourself will fall on your shoulders somewhat. One of the illustrators in this book told me about a prospective client who wanted either his services or the services of another illustrator repped by another agent. This illustrator got on the telephone, called the art director directly and brainstormed ideas with him. They quickly found rapport, and the art director gave him the job on the spot. The art director had actually been leaning toward the other artist before this guy had the street smarts to make the call himself.

Your work must grow and maintain high quality and innovative style to be street-worthy. Your attitude in working with art directors and creative directors all over the country (most of your communication will be done via telephoning and faxing) will either keep them coming back or send them running. Ultimately, the final and repeat sale rests on your broad freelancer's shoulders.

Chapter 5

Keeping Your Skills Current

Are you really ready to go out there and be an effective, successful freelancer? I hate to ask that question, but I do, and often. Many graduating students think that freelancing is the thing to do while they are looking for a full-time job. Nothing could be further from the truth.

Streetwise Design and Illustration Skills

Students fresh from college or design school do not have enough skills or industry knowledge to start their own business. A real freelancer is in it for the long term, not the short term. In fact, I believe that a minimum of three years as a professional designer will just begin to show you enough streetwise ropes to be able to go out there on your own. Successful freelance illustrators have, most commonly, worked as designers for a few years or more before embarking on a solo career. Maybe an occasional "superillustrator" comes out of a

top-notch design school and has an uncle who is a big New York agent, thus making freelancing a viable option, but I promise you this situation is extremely rare.

I wanted to write this book so potential and existing freelancers could find honest information to help them succeed. Quite honestly, what will most help you succeed are your own skills. Review The Top 10 Things Your Clients Will Expect You to Know (on page 76) and don't lie to yourself about how good you are. If you aren't sure, ask for a peer's thoughts. Or better yet, set up a portfolio interview with an art director whose work you admire and ask for a critique.

Corporate clients, ad agencies, design firms and anyone else who hires you to do freelance work will expect you to know your own business inside and out. They will also expect you

Miami Valley Economic Development Coalition *Report to the Community*. Now here is a job where communication skills really prevailed! My partner and creative guru, Chris Wire, took extensive notes from this very conservative and new group. When he presented this "orange Volkswagen" of a piece, the initial client reaction was bewilderment. Could this economic group provide such a bold piece as their first communicated material to the region? Chris answered their questions and concerns very effectively, showing how each design element, while very contemporary, addressed issues that the coalition was endeavoring to communicate to the audience. The outcome was a super creative piece for us and a very happy client group.

to have voice mail and return calls promptly or to have an assistant answering your phone professionally in your studio.

The "right" jobs will require you to be on your toes at all times. Have a separate phone line that you use strictly for your freelance business; no groggy morning hellos from bed—ever. Let your clients know how best to reach you. Invest in a $15/month voice-mail pager so you can get your messages from anywhere in your state; $40/month gets you a nationwide voice-mail service with a toll-free number. If you do a lot of out-of-state work, expecially with clients in different time zones, these gizmos are wonderful.

Clients will expect that if you are freelancing today, you will be freelancing next month— and six months from now. You will receive many projects because your client is too busy to have her own staff work on them. Therefore, a large percentage of your projects will have continuity and domino into other projects of the same nature or theme—good for you, but bad for your client and your name if you decide to get out of the business halfway through.

If you get a great full-time job opportunity that you simply can't pass up, be sure you act responsibly with your client base. You never know when you may need them again—it could be soon! Do your best to persuade your new employer to let you start your new job as soon as your existing projects are finished— probably four weeks. He should respect you for this request because he would want the same type of notice from you. Carefully notify your clients, face-to-face, and share your thanks for the positive experience(s) they have given you. Send thank you notes to your entire client list within two weeks of starting your new position. As I said before, you never know when

you might need them again—or when they may need you.

Hopefully, freelancing will be such a good experience for you that you will always want to pursue it. Freelancing can take many different turns, from freelancing "full-time" at your favorite studio, without the political hassles or responsibilities of being an actual employee, to international opportunities for those with the right attitude, a great agent and a superior portfolio. It happens to a lot of us, and it is an incredible amount of fun. The pay can be excellent also. I remember when I started freelancing, I told my husband so many times how I couldn't believe that people were actually paying me to have so much fun. I still feel that way.

Keeping Your Skills Up-to-Date

Oh, the glories of the computer. It wasn't enough that we had to learn how to have "good eyes," a sense for color, steady hands and flexible-thinking brains. Now we have to be computer technicians, too! Maintaining current computer savvy is very time-consuming but absolutely necessary. New versions of design and illustration software come out at least once a year, and if you're working with three major software programs (which is very typical), that will mean that three times a year you have to catch up on new techniques your software allows you to use. Wonderful, but time-consuming—and costly for the upgrades, too.

THE TOP TEN THINGS YOUR CLIENTS WILL EXPECT YOU TO KNOW

1. Comprehensive knowledge of computer programs including QuarkXPress, Adobe Photoshop, Adobe Illustrator (or Aldus FreeHand).

2. Detailed, firsthand knowledge of the production/manufacturing of printed material, including color separations. (Don't even try to bluff your way through this one!)

3. Different forms of storing information electronically (SyQuest drives, Zip drives, CD-ROM technology, DAT tapes, optical drives, external drives, portable drives, etc.).

4. Your way around town. If you are new to a city or unfamiliar with it in any way, have a detailed city street map in your car. If a client asks you to show up at a printer, know how to get there—don't ask.

5. How to negotiate the value of your work.

6. When and how to listen and make suggestions vs. taking literal instruction.

7. The latest and greatest in computer technology as it relates to your specific industry. (Especially graphic designers. Illustrators not yet illustrating on computers need at least a conversational knowledge so they don't appear to be in the Dark Ages to their more technical clients.)

8. The right questions to ask when you are taking in a project. Don't call a client several times a day with questions you should have asked in the take-in meeting. Don't be afraid to be too thorough in the first meeting.

9. What format your end product should take when you turn it in to your client. Will it be printed, mounted, tissued and covered? If printed, at what resolution? Will you provide a proof? Will you use your own boards and cover stock or your client's? Will your client's clients know that you, a freelancer, did the work? Will you need to keep any information confidential?

10. How to meet a deadline with absolutely no excuses for ever being late.

This may sound like a tough assignment, but these ten points are universally expected. These street smarts are things that anyone in our industry learns on the job—through several years of experience. If you are going to be a real freelancer—and get the going rate for your services (about three times the average hourly rate you would get on the job in most cases)—you better know your stuff!

Trade Magazines

The best way I find to keep current is to keep up on reading the trade magazines I subscribe to. Not an easy task, since there are at least five that I try to read cover-to-cover, but the trade magazines in our industry really do a great job of educating us. They review new software and hardware pertinent to our industry, and ads announce new products and upcoming trade shows.

Trade Shows

Trade shows are another excellent way to keep current. The problem with trade shows is that they are only about twice a year, on either the West Coast or the East Coast, so a considerable amount of money and time may be required to attend. Also trade shows can be overwhelming; seldom is it possible to thoroughly review more than half the show. Check the announcements for upcoming trade shows

in our industry trade magazines, and try one some time. They are a lot of fun and tax-deductible (see chapter nine).

Seminars

Many software companies offer one-day seminars, usually at hotels, in metropolitan areas. These are usually first come, first serve, and most of the reputable ones offer hands-on activities at computer stations. If there is a cost attached to these seminars, there is usually a money-back guarantee. You can't go wrong here. Even if you think you are proficient with a software program, if you have been using it for less than three years, you will learn a sufficient number of new shortcuts to save a lot more than the seminar cost.

Teaching

I find teaching rewarding in many ways, including keeping my skills current. I have never had enough knowledge to teach a technical computer course for designers or illustrators; however, all of my classes have required students to prepare projects in the Mac lab. Being close to anyone under twenty-one years old is a very eye-opening and fun experience, both technically and personally. Most people in college now had access to computers at very young ages, so they are much more adept at acquiring new computer skills than I ever was.

Communication Skills

Originally, I thought learning to listen was something you learned in kindergarten. Not

so. I realize now that I never thoroughly listened until I began my freelance career. Suddenly, I had to pay attention to everything—from what someone told me their name was to technical information being shared at a take-in meeting to what someone else had determined the schedule was. To ask questions that were answered ten minutes ago is just not cool.

The best way for me to remember people's names is to repeat them, as in, "Nice meeting you, Susan," as I really concentrate on *Susan, Susan* in my mind. This is not easy, since being the true designer practically forces me to do everything but remember Susan's name. I want to check out her shoes, the color of her eyes or the intonation of her voice. Then, whammo, I have no idea what she said her name was. Word association seems corny but really works as in saying things to myself such as "My sister-in-law's name is Susan."

Recognizing that you use negative words in conversation is another important key in communicating effectively. Most of us do not realize that words such as *only, just, can't* and *but* are perceived as negative.

One of my first portfolio reviews was with a close peer whom I had looked up to for many years. When I was finished showing her my book, I knew I had done a great job. To my surprise, she informed me that I had said the word *just* almost every time I explained a project I was showing her: "This is just a brochure I did for an industrial waste company."

The word *just* is demeaning when used as a descriptive term. The brochure was one of the best pieces in my portfolio; however, the person receiving my information would think I did not think very much about the piece because of the way I had inadvertently described it.

77

Franklin Hammond
On Being a Freelancer

Frank Hammond graduated from Ontario College of Art as a design major, beginning his professional career with a two-year stint at McGraw-Hill Publishing. After traveling through Europe and painting for a year, he returned home to become a freelance illustrator, a career he has pursued for more than twenty-five years. Frank is very pleased with his agent of six years, Scott Hull. He acquired a European agent two years ago. Frank's clients include Apple and Swiss Salt. An article featuring his work was published in *Step-by-Step*. Frank defines his future in freelancing as "the end of the rainbow."

1. Give us a brief background of your training.

After high school I spent four years at the Interior College of Art in Toronto. I worked for McGraw-Hill in Toronto, and then my wife and I went to Europe for a year to travel and paint. I came back and decided to freelance. I started as a designer as opposed to an illustrator, but I've been illustrating now for twenty-five years. I've asked Scott Hull, my agent, if I should go on computer and he's said no. My illustrations are fairly graphic and they are illustrative. I use objects as well as cut paper, watercolor paper, watercolors, acrylics and different mixed media. Once they're created, I have them photographed so they're more three-dimensional than your average illustration. Scott thinks my work is very unique and distinctive and that there will always be a need for it— which I personally feel is true. I compare it to plasterers. Even though everything has gone to drywall, a good plasterer is always in demand because there are people who are still willing to repair plaster to its original state.

2. How did you get into freelancing?

I've always enjoyed painting, even when I was at art college. I took illustration courses, but simple graphic design is what really interested me. When I landed the job at McGraw-Hill, I designed brochures and things like that. There were a few projects that needed illustrations, and they didn't have the budget to hire an outside illustrator. I did a bit of illustrating, and then I did a bit more. I did well. When I was awaiting my trip to Europe, my wife and I met a freelance photographer from Australia. I said it must be so neat to be a freelancer, and he reminded me that I didn't have a job to come back to. He suggested that I try freelancing. When I came back to Canada that is what I did. I put a portfolio together with design and illustration in it. I started to get more illustration work than design work. I represented myself for a couple of years, and I loved the social aspect of it. Scott has said if I ever wanted to give up illustration he'd hire me as a rep. In fact, when things are dull, I call up clients that I've dealt with and keep current with people.

3. How did you find your rep?

I found Scott Hull by going through *American Showcase*. I

chose a number of reps that I thought my work might fit in with and who handled people I would be pleased with. I phoned the reps and said I wanted to send work. Scott said he wasn't looking for anybody, but I sent my work anyway. I sent my work to four people, and three of them were interested. Two of them were in New York and Scott was in Ohio. I thought I should go to Ohio. I used my talking skills and sold myself to Scott. He was hesitant about taking me on because there wasn't going to be a lot of work coming in right away. I suggested we put my work into a book to see what happened. I knew if my work was in a book, I'd be in.

4. Do you ever have problems communicating with your clients? Please elaborate.
Verbal skills are really, really important. Having a great rep is also really important. If you can't communicate very well with your client, then your agent must. If you have a great agent then there is no problem. Since I've been dealing in the U.S. for the past five years, I've been with Scott and it's been great. I also think it's wonderful for the illustrator to be able to work directly with the designer or art director because the illustrator will ask questions that a rep isn't going to know to ask. I can tell a client that an idea doesn't feel very comfortable to me and offer suggestions on what to do or how to fix it. I have had a lot of projects where I get a manuscript and then discuss on the spot with the art director what I'd like to do. We banter back and forth, and usually by the

time I'm off the phone we have an idea. It's rare that I ever do more than one rough idea.

Most of my communication is done over the telephone—very seldom do I sit down with an art director. I have a rep in London, England, and I just finished a huge four-month project out of Switzerland. That was all done on the phone with a designer who spoke very little English.

5. You did some work for Apple's web site. Tell us about that.
I did the three-dimensional illustrations that appear on the site. They didn't want the illustrations to have a computer feel to them, so first I created them and then had them photographed. The transparencies were given to the design firm and they put them on the Web. I got this project through the *Workbook*. It's an advertising vehicle for illustrators. *Workbook* and *Showcase* are the two major advertising vehicles for illustrators and reps. What we do is take out pages in these books. Art directors look at them and phone the illustrator or rep. Usually the client wants to see a portfolio. The job is then quoted and, hopefully, we get it.

6. In your opinion, what other types of skills does one need to become a successful freelancer?
Well, along with good communication, enthusiasm. Say the client is looking at three different illustrators, and it's a toss-up about whom they are going to use. If the illustrator can talk with the art director, I think that

can make a big difference. I get very enthusiastic and excited about projects even after twenty-five years. It's good for the client to know that. I actually help my rep close sales for me. It doesn't happen often, but there have been occasions when my being in Canada gave them a push. Take for example the Swiss job mentioned earlier. The designer really wanted to use me, so I ended up talking to the art buyer and asked her if she minded if I talked to the designer. The art director and I talked for a bit, and we bantered some ideas back and forth. He felt very, very excited after speaking with me, and the client went for my idea! Also, the client was only going to do half the project at first and the other half later down the road, but the art director sold them on doing the whole project at the same time. If I hadn't been in verbal contact with the designer, I don't think all that would've happened.

I continue to experience personal growth, and I constantly evolve as an illustrator. Because of this, I can still illustrate pieces with a fresh look from one year to the next. I find that there is quite a difference in the evolution of the work, but it all looks visually the same; there is still my style that ties it all together. Think about the Marlboro pack. The pack looks the same to us as it did forty years ago, but if you put the forty-year-old package next to the current one, they are quite different. It is a slow progression of change that keeps the illustrator stimulated and excited in what he or she is producing.

79

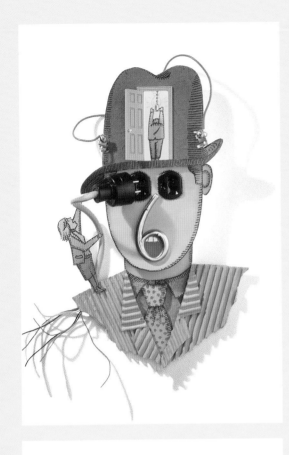

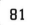

Take the words *just, only, can't* and *but* out of your vocabulary immediately. Ask those critiquing your portfolio, before you begin, to tell you afterwards if you use any of these words. You will consciously begin to listen to yourself and correct this common, yet often ignored, communication problem.

More Effective Communication Tools

How good is your eye contact? Everyone likes to be addressed face-to-face, and what that really means is eye-to-eye. If you have ever taught a class or done public speaking, you know that it is wonderful to have people looking at you. You know they are paying attention and are not bored. Hopefully, you realize this as one of the attributes of a good speaker, because you are also looking back at your audience.

It is more difficult to make eye contact with an entire group, of course, than it is with just one, or a few, people at the table. Consciously take the time—whether there is just one, several or many people in your audience—to look to them for eye contact. You will find that people will agree with what you are saying more often; you will be more believable to them. Begin to be aware of this technique and look at friends, salespeople and loved ones to assess their eye contact habits. Then realize how you are acknowledging what they are saying. Eye contact always prevails as the easiest, most successful tool for effective communication.

Enunciating words clearly is another important thing to be aware of. Many people, especially young women, tend to speak very quickly; a lot of important thoughts and messages are lost in the gibberish. Listeners often do not take them as seriously as may be deserved because they view speaking rapidly as a sign of immaturity. Many of us as adults have a problem with talking too quickly; people close to me tell me that I do this myself. I feel that I always have so much to say, and probably I am afraid that people won't give me enough time to say it all!

Many people have enunciation issues to overcome when they move to different parts of the country. People from the Deep South tend to speak with a definitive accent vs. peo-

ple from the West Coast. Ask those close to you and people from different parts of the country to be honest about your enunciation habits. Once you become more aware of your personal issues, you begin to modify them.

How loudly you speak also affects how people perceive you. How many people do you know who speak so loudly that you are embarrassed when you are around them in public? Then there is the person who speaks so softly that you either believe what they are saying is not too important or decide it takes too much effort to pay attention. These are issues we don't learn in design school, but they are very important and easily corrected. When speaking to a group, make sure you can be heard by simply asking your audience. For one-on-one volume control, ask those close to you to be honest in critiquing your habits.

Beware of Industry Jargon

In our industry, as in others, we have a certain set of words we use as jargon. Some words have a dual meaning to us, but just one meaning to most of our corporate and younger, perhaps less technical, clients. Terms have evolved throughout the years, and some are very old; few are taught in school. These terms range from technical terms such as *dylux* and *iris* to everyday words that have a totally different meaning in our industry.

The two most popular dual-meaning everyday words I can think of, both of which have gotten me into trouble on memorable occasions, are *dummy* and *hickey*. *Dummy* in the design industry is another word for a mock-up or prototype. A hickey is a blemish made by a printing press, specifically a dirty blanket, plate or negative that makes a small blip,

sometimes called a donut, on the finished printed material.

On two separate occasions, a client thought I was calling him a dummy as I was discussing his project, and yet another thought I was coming on to a printer during a press proof with talk of problems with hickeys! In retrospect, these memories are funny, but at the time I was very embarrassed and the clients were obviously angry, while I was completely oblivious to their confusion.

Personality Assessments

There are many varieties of personality assessments on the market. These are available in books, psychology trade journals, educational institutions and seminars. I highly recommend your using at least one of these instruments at some point early on in your freelance career as a means to increase the effectiveness of your communication style.

My personal favorite, probably because I think it is the easiest for creative types to understand, is the Myers-Briggs Type Indicator. Myers and Briggs are both noted psychologists who developed a wonderful study on personality types. Books on their theories are very popular, and their testing mechanism is used internationally to help assess many different types of individuals—from creating effective management teams to helping college students and even prison inmates learn about themselves.

The Myers-Briggs instrument is a test that requires less than an hour of your time. In the test you are asked questions about things you prefer. For example, do you prefer a party on a Saturday night or a quiet evening with your favorite book? The instrument is then

83

SYNNETRY corporate identity. Here again, good communication between designer and client is exemplified by a logo that Real Art's Mark Kargyl created. This business offers a unique service that provides worldwide sales and training of their clients' products via the Internet—thus our name solution, "SyNETry," along with a high-tech-looking art style.

FIVE TIPS FOR BETTER COMMUNICATION

1. Slow down. Learn to listen to your enunciation and to adjust your volume.

2. Do a little research on body language and personality assessments. The time you spend will be more beneficial than you might imagine.

3. Stand up to show your portfolio instead of sitting down. Psychologically, this puts you "in control" of the situation. If you are feeling nervous at all, this is a good way to gain self-confidence during your presentation.

4. Take a short course or seminar in public speaking. Community colleges and one-day seminars are invaluable, inexpensive mechanisms that won't take much of your time and will offer a lifetime of pragmatic skills.

5. Ask your listeners how you can improve your communication style. This will be awkward if you have just met the person. However, when your meeting is almost over, if you feel as though it has been friendly, go ahead and ask. The other person will be flattered that you want their honest input if you tell them so. Remember not to be defensive when you are given advice. The worst thing you can do is make excuses for yourself. Take some notes and graciously thank them for their objectivity. What you will do with their information is up to you—but remember, you asked for it!

graded and evaluated by someone who has been certified to do so.

The end result is a plethora of wonderful information about yourself that you can use on a day-to-day basis as you communicate with others. You will learn why you react the way you do and how to use your strengths more effectively. You will also learn that others you are communicating with have their own personality preferences, and you will be in a much better position to communicate with a variety of personalities. Suddenly, new meaning and good information comes to communication

problems you may be having.

Myers-Briggs, as well as other types of personality assessment instruments, is available through local job counselors, management seminars and career counseling at community colleges. Use your networking skills to discuss Myers-Briggs if you are interested in this enlightening information or other types of assessments. Once you have a better understanding of your own communication processes and strengths you can expand your effectiveness without a struggle.

Chapter 6

How to Be Professionally Effective With Clients

Sometimes it's hard to remember you are a freelancer. Your main objective is to fulfill the client's needs, not your own. Your client knows more about her product or service than you do. The client hired you for one of two reasons: (1) she has a full-time staff that is too overloaded to produce the job you have been given, or (2) she does not have a staff at all and hires freelancers regularly to produce collateral materials needed for marketing, advertising or image building. Again, your client knows more about her product or service than you do; however, many times you will have a better idea on how your client should *promote* her product or services.

The Key Is Flexibility

Being flexible is the key to selling your concepts. Many times a client will have a predetermined idea as to what he thinks he needs from you, such as a capabilities brochure or an advertising campaign. Your perception may be that he doesn't need a capabilities brochure at all; in your opinion, he may need a new logo first.

This testy situation will repeat itself count-

less times, especially if your clients are small business owners. (Remember, small businesses are those that employ five hundred people or less.) Ultimately, you will gain more respect from a client with whom you can share your professional acumen. Surprisingly though, some small business people really don't want advice from other people, and, sadly, that is why they stay small business people. Every freelancer's dream is to be hired for his or her expertise; know that this will not always be the case.

On the other hand, there will be many opportunities for you to educate your clients.

86

An important way to discuss any creative need your client has is to affirm the client's thoughts and perceptions with phrases such as "That's a great idea," "Yes, I understand," "Super." Positive words will make your client think that you are in complete agreement, and you will reach a comfort level together more quickly than if you oppose him in any manner.

You may not like the client's ideas at all. You may disagree completely with him. If you do, after you use a positive phrase, add the word *and* to move on to your own ideas. If you are not a spontaneous thinker and reactor, wait to repeat your client's perceptions in a written summary of your meeting with your proposal, using the word *and* followed by your thoughts on the matter. The word *and* simply ties your thoughts to your client's thoughts. Your client will more easily accept your ideas because you have included his.

If your client's idea is absolutely horrendous, you might not include it in your actual presentation; or you might do two versions of a presentation—one embracing the client's concepts and the other focusing on your own. It will be important for you to acknowledge the client's concept and admit you liked it very much but let him know that with further thought and research you have decided to take another course that better fulfills his objectives. The client's original idea led you to the new alternative. This makes the new idea his own in many ways. Don't get caught up in your personal ownership of a concept in this case. Who cares if it is not the client's concept? Get caught up in its execution instead.

Opportunities to share your expertise in an open manner will not come up very often until you have gained the trust of your client. It will be more important for you to listen and take notes before you respond openly. The more opportunities you get to work with a client, the easier this sharing process will become.

Giving in to your client's desires is not an easy thing to do, but it is a necessary one in many cases. At times you will be absolutely certain that a client's objectives will not be fulfilled with the direction she is asking you to take. You have presented your most professional concepts. She still chooses her own direction. You can either drive yourself crazy insisting that she take another look at your focus, or you can produce the piece her way and then decide whether you will provide services for that client again.

Dealing With Politics

Client politics are certainly something you will encounter, in both large and small organizations that you service. What I mean by politics is something such as a marketing director providing you with information on a project and then a product manager calling you to discuss another set of information that he thinks is more important for you to focus on. (After all, the project pertains to the product manager's product line.) Now, what to do?

Different political scenarios abound. These situations are everywhere, all the time. They do not go away. Many times they are purposely and selfishly motivated. Just as many times, however, these issues arise quite innocently. They will usually take you by surprise. The best way to resolve them is to be street smart, on your feet. In the above situation, it would

This poster for Dayton Opera features the work of Greg Tobias, my all-time favorite illustrator who happens to be on my staff! Greg keeps his skills up-to-date in an impressive manner that wins him a lot of recognition. All of the illustrated work that appears in my company's samples was created by Greg, which shows his versatility and willingness to grow and change. This particular art appears to be hand-rendered but was produced on the computer.

be appropriate to ask the product manager for a meeting together with the marketing manager to pull all ideas about the direction of the project together.

If the product manager declines to meet, you know that his motivations are to go around the marketing manager's back. Thank him for his information, and tell him you will make every effort to include his thoughts in your work.

Since you could find yourself in the midst

of any number of different client political fiascoes, I cannot begin to give case studies for each. When you find yourself in such a situation, you will know it because of the uncomfortable feelings of confusion it causes. These situations can quickly zap your creative flow. Don't let it happen. Find a mentor with whom you can role-play the situation, and take care of it quickly. If you lose a job because of company politics, you probably didn't want it anyway.

Making a Commitment

If you decide to embark on a freelance career, the most important person to make a complete commitment to is yourself. Know that it may not be the easiest thing you decide to do with your life. Know also that success will not come overnight. Do not glorify or glamorize your new lifestyle. If you do, you are setting yourself up for disappointments. Commit to freelancing for a minimum of one year—no matter how tough it gets.

The easiest way to fulfill your commitment is to set realistic, attainable goals. Set goals for the types of projects you would like to produce, as well as for the amount of money you would like to make. Set goals for every three months of your coming year, as well as for the entire year. Do this as soon as you begin your freelance business. Establish goals on a weekly basis.

Make sure to write your goals down so you have them in a tangible format. Studies show that goals that are written down vs. being verbalized are realized more often. Be careful that you are not too hard on yourself, but don't be afraid to dream a little—especially on your annual goals. When you write your weekly goals, review your monthly and annual goals so they are fresh in your mind. At the end of every week, note your accomplishments in a journal. This should take you thirty to forty-five minutes per week, total. It is a wonderful exercise that will help you achieve success!

Committing to clients is at first exciting, then overwhelming. For me, there is no greater high than bringing in a project. It means the client likes my work and trusts that I can produce what she is looking for. It makes me proud that I chose the right career and gives me self-confidence to call on even larger clients. The overwhelming part comes when I sit down and begin to execute whatever it is I am supposed to be doing.

Be sure you commit to a client's project for all the right reasons. If you accept a project that does not realistically fit your skill set, you will be in more trouble than you bargained for. If a client offers you a project that is over your head, either accept the project, knowing that you will learn something from it and also knowing that you will need to pay for the services of someone who can help you, or decline the project and recommend an expert who might be able to accept the assignment—if you know one. Clients will respect you for knowing your limitations. This is the perfect time to review your specialty with the client and thank him for thinking of you.

Committing to clients' schedules is yet another hurdle to overcome. For some unknown reason, most projects that come your way will have quick turnaround schedules. I suppose one of the reasons evolves from the history of creative people doing their best work under pressure. Most of us will admit to this phenomenon.

If you agree to produce a freelance assignment within a schedule given to you, do so without being one minute late or making excuses for yourself. Being late even one time will be the precursor to your not providing services to that client again. Schedules in our industry are never to be taken lightly. If you know that the schedule is unrealistic, say so and explain why. You probably can buy some more time by doing so and gain more respect from those working with you in the meantime.

Committing to family and friends that you

are going to become a freelancer may be something you never thought about. Why should they really care? The answer is twofold. Committing to them is really another acknowledgment to yourself that you *are* going forward into a freelancing career. This also is a great time to lay some ground rules for them, especially if you are working from home.

Learning to Say Yes and No

I had a design instructor who encouraged us never to turn down a freelance opportunity of any kind. He told us that if someone trusted us enough to give us a project, we should take it on and find a way to get it done. I will agree with this philosophy only if you know you have the street smarts to find the way to get it done. Have you maintained close enough relationships with old profs and instructors who can help you find the information you need? Admitting your deficiencies to other professionals in your area could get back to your client and be rather embarrassing.

I do agree that when you start your freelance business you should say yes to absolutely everything that comes your way, whether or not you are completely in love with the project. The foundation of my own freelance business was with production projects, which I loathed because I wanted to sell myself as a designer. Producing projects, however, introduced me to clientele who would later hire me for design assignments and helped me get established— not to mention put food on my table.

The bad thing about agreeing to do everything is that you might find yourself overloaded. As soon as this happens, you can start allowing yourself to be a bit more selective. You will need to get through this rough period by pulling some all-nighters and turning down some social opportunities. The payoff will be well worth it!

FIVE GROUND RULES FOR THE HOME FREELANCER

1. Establish hours for your studio time during which you will accept no interruptions.

2. Set off-limits boundaries, especially for kids and pets, within the physical domain of your creative environment.

3. Insist that if your door is closed, others are to tap very lightly before entering. You may be on the phone or working intently when a sudden interruption could frighten you into making a huge mistake on your artwork or cause you to respond unprofessionally to the person with whom you are endeavoring to have a telephone conversation.

4. Set up a separate phone line in your studio that is for your use only. Use an answering service or machine for times when you are away.

5. Make it clear that all art supplies and/or your computer are for your use only—unless you agree that they may be used under your close supervision. Imagine the fiascoes that could result!

Photo by: Scott Hull

John Ceballos
On Being a Freelancer

John Ceballos has been freelancing since 1988, providing creative solutions in the advertising and editorial sectors of illustration. He taught various design and drawing classes at Napa Valley College for five years and has held corporate art director and designer positions, respectively, at Gibson Cards and Hallmark Cards. A partial client list includes General Mills, McGraw-Hill, *Time* magazine, Ralston Purina and the National Geographic Society.

1. What is your opinion regarding being flexible in the freelance industry?
Being flexible means using your creative skill and your point of view—your style as it were—as a starting point, a foundation. That way, whether or not you're illustrating a thermometer or Atlas holding up the world, it's still your input and creativity that is evident and expected by both the art director and the client. Whether the subject matter is mundane or exhilarating, the client has chosen your portfolio—your point of view—to express their ideas or product.

I keep my schedule flexible enough to accommodate a client's desires. I let them know that each assignment is a priority with me despite budget. An art director I know was flabbergasted when the freelance illustrator said he wouldn't make the deadline agreed upon because a bigger budget job had

come in. She wondered, " I called him to double-check that I was getting the art soon—was he going to call me?"

2. How do you share your expertise with a client who is not familiar with your work?
Through effective communication up front, discussing a specific idea or direction verbally or, better yet, a thumbnail sketch provided by the art director. It's a bad feeling when, after several sketches, you begin to realize that as far as your being on the right track—they'll know it when they see it. My sketches are very literal. Pencil lines indicate reasonably accurately what the thicks and thins of the ink line will do. An art director knows what to expect and isn't surprised or confused by the finish. Color is discussed with the help of a Pantone color guide. I also maintain a cheerful, open dialogue with them so they can

feel at ease sharing any information that may be pertinent to our relationship.

3. Please share some tips on knowing when and how to say no to clients regarding any freelance issue that you feel strongly about.
Fortunately I've never had to deal with an issue so divisive that I would have to shun the assignment or project. Lack of funds and a history of slow or no payment are the main deterrents to working with a client.

4. You were an art director for Hallmark and Gibson Greeting Cards. How does freelancing now fulfill your ability to be effective for your clients after all of that corporate experience?
I have gained a lot of maturity from my experience as an art director and freelance illustrator. I'm flexible, yet calculated. I have a strong sense of what's

Untitled

"Cow Planning His Trip Over the Moon"

my visual communication skills. Afterwards, conversations that I have with the art director, identifying their goals and expectations, help to assure effective on-target results.

8. Please share an example of a freelance experience in which you were *not* effective and explain how you would handle things differently with the knowledge you have now. I recall doing a series of sketches for an ambivalent art director who led me through a myriad of sketch directions—styles, tweaks, modifications and redo's. This led to color roughs and three finishes. Needless to say, the client wasn't happy, I wasn't happy and a portfolio piece wasn't there. In the future I need to second-guess an upcoming outcome such as this and use my ever-expanding intuition to head it off through better communication. This would include letting the client know that additional sketches can result in additional fees being charged.

appropriate and expected based on the needs of the client I'm working with. As a rule, my characters aren't way-out wacky or weird. My colors aren't jarring to the eye nor are they passive and muted.

5. How do you follow through with clients after the project is over? I send new samples and a personal note along with the artwork and then follow up with a phone call.

6. Do you use intuition at all as a decision-making tool in your freelance business? My intuition is based on experience and expectation. This keeps communication effective and sketches and glitches to a minimum.

7. What would you say is your primary method for showing prospective and existing clients your effectiveness? Directories followed by a portfolio give a clear indication of

In the future, you might agree to continue to take on menial work and find an assistant who is interested in helping you. You can find able and willing assistants at the design school or college nearest you. Sometimes having an assistant can be great because an assistant will answer the phone when you are away and fulfill tasks you might not enjoy doing yourself. Just remember, if you are not a patient person and do not enjoy teaching or explaining yourself, an assistant is definitely not for you.

Saying no to a client doesn't have to be the end of the world. If you need to turn down a project because the schedule is not appropriate for you, suggest a better schedule. If the project does not have the budget you believe it deserves, propose a more realistic budget. You will be surprised at how many times a client is looking for some direction in scheduling and budgeting anyway. Many times you will land the project on your own terms just for the asking!

Educating Your Client

You probably never realized that you would become a part-time teacher when you committed to starting your freelance career, did you? This may be the most frustrating task you will encounter. Teaching the value of good design—what it is worth in dollars and cents—along with teaching others to trust you can be a humbling experience. The truth of the matter is, though, that the teaching never stops. There is always a new situation or client that requires you to begin the educational process again.

Agreeing to initial budgets is a tough hurdle for many clients to overcome. Even corporate clients with huge overall annual design budgets can easily get hung up on how much they are going to pay you. In their eyes, you are a self-employed person with little or no overhead and they should be able to get your services cheap. Just remember that once you provide your services at a reduced rate, you may be obliged to do so more often than you had in mind. If you decide to provide discounted services the first time you work with a skeptical client, be very clear that the budget should have been more substantial and that any future services you provide will be billed at a more realistic rate.

There is a pricing manual used throughout our industry called *Graphic Artists Guild Handbook of Pricing & Ethical Guidelines*. This publication is updated annually and shares parameters for pricing projects that might be helpful to you starting out. Beware that the prices quoted are generally on the high side and are for established designers and illustrators. This is to your advantage, because you can share this publication with your clients who are giving you a hard time regarding your rates.

The actual value of graphic design and illustration is the most difficult aspect of our business to explain to others. I always try to create an analogy for my clients that they can relate to their own business. In the case of a furniture store owner my analogy was, "I would not come into your store and declare that your prices on leather sofas are too high, because they are not. They are high-quality leather sofas, imported from Italy and priced fairly." This was a client who constantly claimed that I was trying to get rich from his small advertising account.

An analogy I used with a builder was, "If I were a customer, building a home using your

services, and I decided I did not like the location of the bathroom, changing its location from the east side to the west side of the home, would you not charge me for that change?" This conversation came after he had approved photos for his brochure and then decided upon seeing a color proof of the entire brochure that he would like to change photos, but not pay for the change.

I do not want to unfairly point my finger at the small business owner or marketing client. There are just as many uneducated corporate design and illustration buyers as well as senior executives (who you probably think should know better) who have surprisingly little knowledge about not only the going rates you deserve, but how to set realistic schedules and what the various stages of your creative process will entail.

When I meet a new client, I am careful to admit that I am not sure what parameters he is used to. I do not talk down to the client, but I explain that this is how I go about providing services. No one seems to mind my clarifying how we will do business together. It is very smart to get it out in the open up front so that everyone is very clear about what the roles and expectations are for both sides of the table.

Your proposals and contracts should reiterate these parameters clearly and concisely. See chapter nine for more information on contract details.

Being the Best

I cannot encourage you enough to always provide the best service, the best work, the best attitude, the best pricing (I do not mean the cheapest pricing here, but rather the best

value) and the very best of every little detail you can think of in serving your clients. If you can consistently provide the best of all worlds to your clients, you will grow into the luxury of having clients pursuing you instead of vice versa. You will be able to choose the types of projects you wish to produce. You will make the kind of money that will keep you happy and, thus, you will be successful.

Skimping on quality, having an up-and-down attitude and arguing for appropriate budgets rather than strategically negotiating, will keep you in the throes of mediocrity, where most of the general population of freelancers is. You deserve to be one of the best in your area. Move forward with that as a constant goal. You should not have to tell your clients that you are the best; as a matter of fact, to do so will bring suspicion and doubt your way. Simply show your clients that you want the very best for them by providing the very best of everything.

All that you have read about so far in this book ties into your capability to be one of the best freelancers your clients work with. Set your standards from the very beginning. Let your clients know that you charge what you do because they are going to receive x, y and z instead of just x. Fulfilling objectives that you have established together for the piece itself, the schedule, how your first presentation will be formatted, etc., enhances your image of being best.

In other chapters I have given tips on following through with your sales and marketing efforts. Following through after you have completed a project is equally important—even if you have provided the client with a lot of work in the past. You can show others that you are specifically concerned and caring about a project, even if you know it has gone well.

95

Wait until about a week after you have turned over final materials that were your responsibility. Then make a phone call and either set up an appointment or luncheon to follow through on your specific project.

Intuition—Your Strongest Ally

Many times people ask me what my biggest piece of advice is to freelancers starting out. My answer is always the same—use your instinct. Everyone has had a situation in which they had a gut feeling about something for no rhyme or reason. This is your intuition talking to you. It is an invaluable tool. I have had many people tell me that they did not know how to use their intuition. My answer to them is that of course they know how, they are just afraid to surrender themselves to it.

There are any number of books in the self-help section of your favorite bookstore or library that will help you explore your particular intuitive strengths and weaknesses. A book I am particularly fond of is *Feel the Fear and Do It Anyway* by Susan Jeffers. You will also get a better understanding of intuition and how to use it if you participate in any of the personality assessments such as the Myers-Briggs test mentioned earlier in this book.

Relying on intuition is your strongest ally because it is your most personal ally. When I have had a conflict regarding a freelance issue—whether a political issue with a client, a question of whether to take on a project, wondering if a client was going to have the resources to properly pay me within my terms—using my intuition usually resolved the problem to my benefit. On the other hand, during those times when I have known deep down the answer was one thing but I chose to act on another, I have always gotten into trouble.

Linda Souders
On Being a Freelancer

Linda Souders has been a freelance art director/ designer for a variety of clients across the country for more than two years. Prior to her freelance career she had extensive experience at two well-known agencies as well as being an art director for Macy's in New York City.

1. What is your opinion regarding being flexible in the freelance design industry?
Being flexible means working with the client's budget, time frame and personal style. Part of the challenge and excitement of being a good designer involves creative problem solving with time, money and personal relationships. Finding new ways to produce specific ideas within a budget and time frame keeps one fresh. My flexibility starts with everything and ends only upon approaching the point of diminishing returns.

2. How do you share your expertise with a client who is not familiar with your work?
At the start of a new relationship I will have a talk with the client, walking them through my years as a designer and what I've done through an overview. As specific issues arise throughout the project, I will relate specific valuable, hands-on experience that relates directly to the issue at hand.

3. Please share some tips or

an opinion on knowing when and how to say no to clients.
Saying no is tied into my "win-win" attitude toward working relationships. If something is not feasible, I will educate them, tell them why, with facts, and try to come up with another positive, more realistic solution for both of us. It requires both parties working together to find mutually satisfying solutions.

4. How do you go about teaching an inexperienced client about how to work with freelancers—namely you.
At the onset I sit down and go through the whole process and how I normally work for greatest success. The client may have their own ideas for working successfully, and then we compare notes, debate and come to an agreement on project structure. Then the specific details within that structure are agreed upon. Preproduction is the most important phase of the project. Once the working system is fleshed out, then each step should fall as smoothly as possible into

place. I don't like to leave anything unresolved up front because unresolved issues create opportunity for problems. And when I am in the midst of a project, I don't want unnecessary problems diverting my attention. Sure, problems will usually arise, but the more ironed out the project is up front, the fewer problems there will be to work out during production; thus, a clearer, cleaner focus and better end product.

5. How do you show your clients that you are appreciative for the work they give you?
By doing a great job! Beyond that, my way of expressing appreciation runs very traditional. I may tell them so in the course of a conversation. Or through a note in the mail. Sometimes I send fresh floral bouquets or bring sweets to meetings. Occasionally I throw in a logo or piece of work at no charge.

6. How do you follow through with clients, specifically during a project and then after it is over?
During the job I keep

Announcements

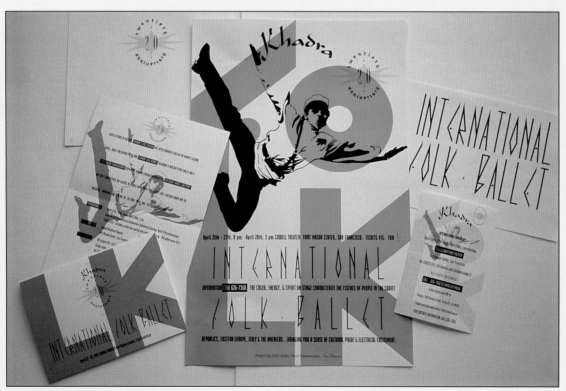

Khadra International Folk Ballet identity system

THE STREETWISE GUIDE TO FREELANCE DESIGN AND ILLUSTRATION

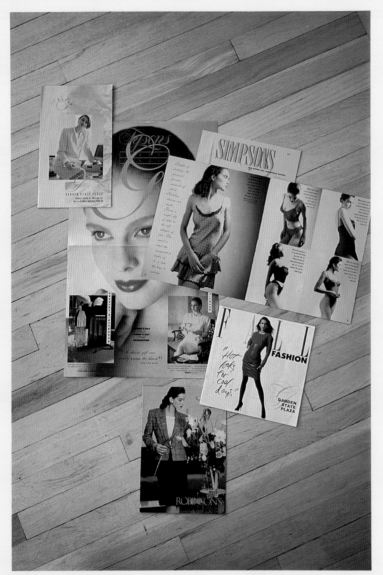

Fashion catalogs

8. What would you say is your primary method for showing prospective and existing clients your effectiveness?
For prospective clients, I think just the way I approach them speaks volumes. I try to come up with unique ways to reach them by how I word a mailing or fax (humor is effective) and at what time I choose to reach them. After lunch is good—they are a little more relaxed and satisfied and then a little more open. Friday, late morning is good. I might send a box with a note and a little something, too. It starts with being an effective person; being reliable, dependable, professional; being punctual, attentive, focused. Participating actively through verbal communication in all facets and phases of the project. Communication is key. Listening to what the client is saying, requesting; asking for, clarifying their perspective and then using experience, knowledge and initiative to produce results throughout the entire project.

9. Do you think being a freelancer is better than having a "regular job" in regards to proving your effectiveness as a designer? Why or why not?
No. I think either can be a forum to prove my effectiveness because I take each project individually. Each project that comes along is a new challenge. "One is only as good as one's last project." Effectiveness is a never-ending challenge. That is part of what make this profession so fun and stimulating.

communication lines as open and active as possible. When the job is over I have a "post-mortem" meeting to reflect on what worked, what didn't and how to refine our working system. After that I touch base every so often with a phone call, a note, or a promotional piece.

7. Do you use your intuition at all as a decision-making tool in your freelance business?
Yes. My individual style of creativity stems very much from my intuition. I always use it as a starting point, whatever gurgles up from my intuition. I then run through the cerebral mill of research, studies, facts and experience. The two together are stronger than each individually.

HOW TO BE THE BEST FREELANCER AROUND

- Ask your client early on if any facets of the project particularly concern him regarding his giving the project to you. Be sensitive to these concerns throughout the project so you can put them to rest and gain the confidence of your client.
- Don't argue or show your impatience with a client. If your client is not following your methodology or is not happy with something, listen to his grievances objectively. Depersonalize his remarks. Constructively educate via the written or verbal word, whichever is your strong point.
- Don't be afraid to take criticism. Tell yourself that every time you are criticized for something you will look at the situation with an open mind. Sometimes this is better done away from the person who is criticizing you. Acknowledging criticism to those who are giving it to you validates their issues without your necessarily agreeing with them. A simple "I understand where you are coming from," is usually enough to bring all parties great relief.
- When following through after a project is finished, be objective. Ask to have a "wrap-up" party that you host if the project was particularly large and ongoing. Be open to comments and sharing your own insights.
- Never skimp on the time or attitude you give a project. It will certainly show in the end result.

What about those plaguing times when others offer "I told you so!"? There is nothing more aggravating, yet we can all remember a time or two when this phrase terrorized our very being. If you use your intuition and follow your little inner voices, you might never hear this again. The outcomes of your situations will be outcomes you can accept and embrace as your own; consequently, you will not discuss them as failures or unfortunate circumstances, which greatly reduces the times that anyone can say they told you so!

Take some time to research what intuition is and how to use it properly. It will be a skill that you never forget, that you will constantly improve upon and that will last a lifetime.

Chapter 7

How to Manage Your Time

Good time management is very basic. There are a thousand books on the subject, but I have tried to glean streetwise advice from my own history as well as from the other freelancers featured in this book. Yes, there are certain rules you can follow for successful time management. But I think it's mostly following common sense and, even more important, applying the skills I discussed at the beginning of this book—organization and self-discipline.

Knowing Your Own Work Process

It is important to be familiar with and accommodating to your own work process. Do you spend a lot of time planning and thinking about a project before you actually begin? Do you do several thumbnails or several hundred? A lot of your work process was probably taught to you in school or by an art director at a previous job. It is time to embrace your own work process— you're the boss now! Find the methodology that works best for you and stick to it.

Achieving success at freelancing won't come with putting in just a few hours a day, nor is it guaranteed when working fifteen hours a day. As a matter of fact, committing to a certain number of hours per day or week probably won't work at all. Learning flexibility is very important at this time. The number of hours worked is of minimal importance to the successful freelancer. The *effectiveness* of your time is most significant.

If by now, after all your reading, you are still reticent to keep a calendar, forget time management. I mean it—just forget being efficient. Your other option would be to take on just one project at a time and completely finish it while doing absolutely nothing else—no networking or meeting with clients about other

possibilities, no talking on the phone about prospective work. A calendar allows you to do effective multitasking by reminding you of important obligations. Your commitment to participate daily in your calendar's evolution is key to using your time effectively.

Paperwork Know-How

Hopefully, you started your freelance business for reasons other than getting away from filling out forms and performing other administrative tasks. Now is not the time to throw these valuable tools into the trash domain. If your freelance services take you on location, to other design firms or ad agencies, your competence and understanding of the proper forms common to our business are essential. If your freelance endeavors find you producing most of your work in your own studio, developing a couple of your own forms will help you save a lot of time.

Every place I have worked, including in-house corporate design departments, used all of the following forms to run a tight ship of organization and efficiency.

A Checklist of Forms You Should Be Familiar With
- ❏ New job/log forms
- ❏ Time sheets
- ❏ Purchase orders
- ❏ Service bureau requests
- ❏ Your checkbook register

New job or log forms simply assign a tracking number to each project. This number will be input electronically by companies that use a digital job tracking program; will appear on time sheets, purchase orders and service bureau requests; and is probably coded on the check register when bills are paid that pertain to that project. This form is a simple list identifying client name, project name and job number. (Don't make it more difficult than it needs to be!)

Time sheets are either manually prepared or input into a software program that generates profitability information during a project and after it is completed. Generally, they are broken down into task functions such as client meeting time, brainstorming, design, illustration, copy, administration, Photoshop/color work and production. Different per-hour dollar amounts are assigned to each task, and when a project is completed it is compared to the original client proposal. Billing adjustments can then be made and justified, if necessary.

Purchase orders are forms that are usually generated in triplicate and prepared manually. If you want your business to be profitable, purchase orders are key. They include any vendor or outside source from whom you are buying goods or services. Any time any item leaves your studio requiring services of any kind, or any time you request products or services of any kind, a purchase order should be used to document that purchase.

On each purchase order, document the date, the vendor, the log number, the quantity (if applicable), and, most importantly, the price along with any other details about your purchase. You may need to phone your vendor for the exact price. Don't guess or just write something down because you are in a hurry. As vendor invoices come in, they are matched

A REVIEW FROM PREVIOUS CHAPTERS

Countless pieces of advice in this book are, in effect, time-savers, such as the personal management issues from chapter one. Being distracted easily, having a messy workspace and having a complacent or lackadaisical attitude are all time-gulpers. Developing self-esteem may take some time up front, but it will save you heartache and a lot of more valuable time down the road.

Establishing the proper studio environment (chapter two) ties into an issue of time management with the decision of whether to have your studio inside your home. Setting limits with your family and loved ones will save an abundance of time and confusion. The decision of whether to have a computer in your studio or to use one from another location will obviously have a big effect on time.

Taking responsibility to find markets for your freelance services (chapter three) requires time, but it will save time in the long run, as will proper follow-through. Building your business from a comfortable niche is also a smart way for you to get on your toes and establish your methodologies for effective time usage.

Having an agent (chapter four) can be a huge time-saver. Your focus will be your own creativity and the projects at hand. No longer will you be concerned about developing self-promo pieces, doing billing and performing other administrative tasks. A good agent will cost a percentage of your fees, but the time saved might outweigh the costs to you. It depends on whether you enjoy (or are good at) the tasks offered by an agent.

Keeping your skills current (chapter five) is another big time-saver. Producing good freelance design and illustration services is not quite like riding a bicycle. It is more like playing golf or tennis. You have to keep doing it over and over to get better. Computerized production tasks are constantly being simplified and their waiting time shorter. That means more time for you.

Educating your client before you begin a project (chapter six), about your process, the services you will provide and what your expectations of your client will be, is also a time management practice. So is your decision to be one of the best—remember the old "haste makes waste" cliché? It pertains to our industry in a big way!

103

to purchase orders for accuracy. Many vendors overcharge by error, charge rush fees that perhaps your client should absorb or charge restocking or change fees that also should probably be absorbed by your client. If you don't use a simple purchase order system, you are probably cheating yourself out of a lot of money, especially over a year's time.

Service bureau request forms are usually provided by the service bureaus themselves (type houses, color separators, printers). This form outlines all production details of your project request—the software program used, fonts required, finished and folded sizes.

Your checkbook register is your most valuable friend when it comes to your bottom line. Do not get into the habit of not balancing your freelance business's checking account. If you absolutely despise this chore, share the task with someone whom you can trust, and be

prepared to pay them something in return. Banks make mistakes—more often than you think—and you will save invaluable time, confusion and credibility if you keep your checkbook register clean and current.

Planning Ahead

Before you start a project; research it for any red flags that might create time-consuming situations. Using special techniques you may not be familiar with and working with a new photographer, copywriter, printer or other vendor are situations that might be sources of timing problems. Be proactive by looking for potential pitfalls of this variety that could burn you out or frustrate you or your client. Introduce yourself to that new photographer, and familiarize yourself with his portfolio and client list. The same goes for the special techniques or other new vendors.

Knowing the right questions to ask before initiating work is also invaluable but not always easy. I find it most productive to take in a new job and let the client talk more than I do; I write notes and interject a few comments pertinent to the subject matter at hand. When the client is finished, I might ask questions that have popped into my mind. More often than not, I tell the client that I will take this back to my studio, study it carefully and then compile a list of questions or issues for discussion. I then fax it for a later phone conversation or meeting.

Some Popular Questions to Ask

• Will the client determine the final size of the project or will that evolve from your design recommendation?

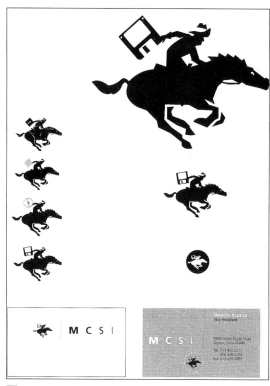

These are original ideas for the MCSI company.

• Will the client buy and/or manage the printing? If so, ask for a nominal fee to follow through with color separations and printers by providing color and press proofing services. I have never had a client turn down this request, and I find that most clients appreciate being relieved of this stress in exchange for my hourly rate.

• If there is a tight schedule, does the client know what his responsibilities are up front so that he might have ample time to prepare? That is, when will he release copy, give a final proof to middle managers, sign off on the final, and so on?

• What should your final format to the client be—diskette, optical, CD-ROM, transparency, film?

• If your client is providing the finished version, can you expect at least twenty-five

Presentation Products

4750 Hempstead Station Drive
Dayton, Ohio 45429

Tel 937 291 8282
800 875 5211
Fax 937 291 8251

4750 Hempstead Station Drive
Dayton, Ohio 45429

4750 Hempstead Station Drive
Dayton, Ohio 45429 **Joanne Fecke**
 Customer Service

Tel: 937.291.8282
800.875.5211
Fax: 937.291.8288

4750 Hempstead Station Drive
Dayton, Ohio 45429

Computer Supplies. Right. Now.

The MCSI corporate identity materials. Our flexibility and commitment to providing a creative solutuion we could all live with resulted in these pieces. While we still preferred the crisp art approach to the logotype (as seen on page 104), the client was keen on seeing their acronym as the focal point of the identity (this page). *C'est la vie!*

samples? Explain that this is for your use as an example of your work and also for entries in awards programs.

It is up to you as a freelancer to take the horse by the reins concerning the comprehensiveness of the services you are providing. Proofreading, color checking, sizes output by service bureaus or other staff people, confirmation of production specs, etc., are all ultimately your responsibility—even if you did not provide or manage these services to begin with. Being thorough and detail oriented are attributes that clients appreciate and don't forget. You will be the first person pointed to if the printer prints the project the wrong size or if there is a typo anywhere—remember that!

So You Have Waited Until the Last Minute!

A significant amount of space was given to the subject of procrastinating in chapter three. For those of you who find yourselves in this painful situation, read on. Unfortunately, for any number of real reasons, important projects sometimes get pushed to the last minute. However, you must not make it common practice, even if this has been your usual modus operandi in the past. You will be too busy multitasking or fulfilling other responsibilities not to have your projects properly organized for the most part.

The surest way to get you out of the procrastinating habit (if it is one) is to be put to

shame in front of your most important client—in other words, to be caught in the act. Picture your client dropping by your studio to see how things are going a day or two before your big presentation—and for whatever reason, you haven't even started. Believe me, your client won't care what the reason is. The end result is your humiliation.

Picture your client calling the day before your project is due to inform you that his boss is going to be out of town tomorrow and needs to see it today instead, even if it isn't completely finished. Once again, your knees turn to jelly. These situations occur all the time. It will take just one time for you never to do it again.

If you find yourself in this situation, it is imperative that you take it seriously and not try to laugh it off with your client. Very seldom do clients take their projects this lightly, especially if they do not understand or normally work with creative types. They will think you are absolutely nuts! If you get caught, admit your fault, assure your client that you are giving the project your top priority and you are confident that they won't be disappointed. Be prepared to be chided about your price or the quality of your presentation, even if it turns out to be the best work you have ever done; your client will be arguing from a standpoint of principle.

An untimely misfortune such as this projects an image of disorganization, lack of setting priorities, lack of care and overall incompetence. Save yourself further headaches by never, ever making excuses about why you have waited until the last minute to begin. Never tell a client you were too busy or that another, larger project got in her project's way. Think of being in your client's shoes. After it is all

Geoffrey Smith
On Being a Freelancer

After graduating from the Art Institute of Pittsburgh, Geoffrey Smith spent twelve years as a designer and illustrator for a plastics company, a department store and one of his area's leading graphic design firms. Geoffrey is now represented by Scott Hull Associates and focuses full-time on illustration for clients such as RCA, Microsoft and *Better Homes and Gardens*, to name just a few.

1. Discuss some of your own work habits.

I've always had a hang-up, best explained with this analogy: I was afraid to hit a home run, or that if I hit the home run I wouldn't want to run around the bases, or I'd get to third base and walk off some other direction. The worst habit I had was never finishing. I'd get something started and never finish it. That was about five years after I graduated from school. Then I became determined to work for five more years on trying to start something and finish it before I moved on. I had to force myself to finish it. In this field, time frames and deadlines help. I constantly dedicate myself to getting the best job done—on time.

2. How do you discipline yourself in regard to time management?

There is a trick somebody taught me. You find a room and you do only one thing in it—work. You don't read a maga-

zine. You don't eat or drink. You do nothing in there except work. It may sound like something a dedicated nut would say, but you need to do this consistently. Before you know it, you're taking yourself into a new place of art. Sure I'd like to use my room to work on my bike (I cycle all the time), but if I did I would be constantly distracted. So the only thing I'm allowed to do in that environment is work. Generally, the children are supposed to tap on the door. They know when the door is closed, there is to be no screaming or jumping around. I try to instill in them that when I work at home it's no different from when I used to work at the studio. I'm leaving now and I can't stop until five, because if I stop early then I'll have to work late, and I don't want to have to work late. Usually at 5:30 I quit, regardless, unless I'm on the very verge of finishing a project.

3. How do you establish your schedule?

I try the basic hours, 9 to 5, but my studio time is usually dictated by whatever has to be done. I don't like to work non-stop like a workaholic. I don't think that's right. I try to schedule a lot of appointments early in the morning because it will get me up and get me out the door. I have to be somewhere, and when I come back, I'm already up, mind and body, and all's in motion. I put my schedule on a big erasable board that shows two to three weeks. I put an estimation of how long I think it will take to get the job done, leaving a little buffer in there, and rate out the price that way. Year after year of doing it over and over again, you kind of get a sense of how long it takes you to do a job. I work six hours a day in illustration and two in administration. I'm very good at organization, I think because my dad was a CPA, so I have a really good background with numbers. Most people in this line of work don't have a business background. My dad

107

thought I would be a CPA or an airline pilot. I seemed to be heading that way. Then all of a sudden I did a 180 degree turn and went into art.

4. How did your prior work experience help you with your freelance business?

When I worked at the design firm, I purchased all the supplies. I had a great feel for what things cost, as well as knowledge of what kind of things you need as an illustrator to do a job. I feel I got lucky by buying supplies. When I started to work there, I was in production. Then I moved up to design, and that's when they started having me buy supplies. I developed a really good sense of what it takes to run a whole studio. Now when I quote a job I try to figure how many hours I think it might take me and come up with a figure that I think is fair.

5. What are the pros and cons of procrastinating, in your opinion?

The pro is I seem to perform the best when I wait until the last minute—the hotter the fire the better. If it's mayhem, it's a great time to put on some head-banging music and make it worse. You push it to the max and see what you can pull out. The con, unfortunately, is that if

you have a ten-hour job and push yourself into four, yes, you can get it done but you know at the eleventh hour you're going to sit there and think, *You know, if I had a half a day to sit there and really work on this thing the way I wanted. . . .* Yes, I put things off, but it's some internal drive that helps things get finished. I'll be working on a job and, at 2:00, getting nowhere, I'll get up and walk away and come back at 4:00 and am able to still get the project out that night.

6. Is taking time off important?

I think taking vacations and getting away from time to time are very important to regenerate and collect your thoughts. We take at least two, maybe three vacations a year, in addition to the long weekends. I rarely don't take a job because I'm too busy. I have a hard time saying no because I know I'm going to take the time off later. You just have to arrange your time off and be up front with clients. I never interrupt a vacation for a project. I've seen some people just work and work, and yeah, they make good money, but I think they're missing the original intention of freelancing. They went out on their own because they liked it and wanted to do it to become better at it. Then freelancers

start taking on other jobs that will help their portfolios—which they have to do—but the original theory gets lost.

7. Share your best advice for freelancers.

The best advice I can give to being a good freelancer is to get yourself to your work environment at the same time every morning, whether you have work or not. This gives you time to create things to better yourself. My going to work at the same time every day is showing myself that I'm dedicated and disciplined, and before I know it, everything starts falling together.

8. What is the biggest advice you can give freelancing fathers?

Don't be hard on the kids for not understanding what you're doing. I think sometimes we try to treat them like adults, and sometimes they act like adults, but in most cases they don't. They have the knowledge but not the understanding. I think they understand that even though I don't leave the house to go to an office, I'm still working. Sometimes, when I worked at the studio, they would go in with me and draw. Now they understand what I do and that working at home is no different.

BRIGHT IDEAS

TRUE STORIES FROM
THE INDIGLO® NIGHT-LIGHT FILES

1995

A GIFT FROM TIMEX PRESENTED BY ACCESSORIES

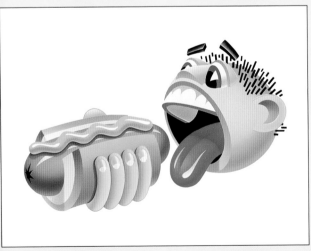

FIVE TIPS ON MAKING THE MOST EFFECTIVE USE OF YOUR TIME

1. Delegate. Even if you work by yourself from home, delegate as many tasks to others as you can. (Try hiring a stay-at-home administrative assistant.) Stick to what you do best.

2. Keep a comprehensive Rolodex file, in alphabetical order. The most efficient way to do this is to use actual business cards from clients and vendors. Write e-mail addresses or other special notes on the back.

3. Get a toll-free voice-mail pager system. If you are a busy freelancer and spend a lot of time away from the studio during business hours *or* if you want to enjoy uninterrupted time, this tool will pay its nominal monthly service fee many times over. This will save you from time-costly phone tag and frustrating phone interruptions when you are in your studio. If your work is produced for all local or regional clients, you will need a local pager service, not a national toll-free service.

4. Prepare for a certain number of pro bono projects quarterly or annually, and learn to say no to the rest. Be firm. If you are interested in supporting a particular cause but have filled your pro bono slate, ask to be called a little earlier the next year so you can plan for it. You will be respected for this consideration.

5. Set up a favorite time of the day to initiate and return phone calls. If early morning is a down creative time for you, make your phone calls then. Let your favorite times of the day work for you and your productivity.

over, attempt resolution by sending a clever acknowledgment of your error.

Another "never" in this stream of advice on last-minute faux pas is to never, under any circumstances, admit smugly or otherwise that you prepared your client's project as your carriage was turning into a pumpkin. Some freelancers think this is something to brag about when a client loves a project and thinks they worked for two solid weeks on it. Don't be silly—such an admission will find you quickly falling into a vortex of disrespect.

Taking Time Off

I am so tired of hearing people make excuses about why they don't take vacations. Vacations don't have to be diving jaunts in Fiji. They can be a stay-at-home, unplug-the-phone, snuggle-in, cook-in, whatever time! A vacation can truly be whatever you need it to be. You're the creative one—you make it happen!

Plan a few days off around a photo shoot in a neat area, whether an unexplored place near your studio or far away. Maybe your kid's school needs chaperones for this year's Washington, DC or camping trip. If you can't afford time away at a vacation destination, take advantage of these opportunities.

The most important thing about taking time away from your freelance business is just that—taking time *away*. Creative people need new stimulation and environments to keep from getting burnt out and to keep ideas fresh. Even if the camping or DC trip isn't all that

These ads produced for Universal Studios' CityWalk are examples of waiting until the very last minute and really learning a lesson for ourselves. Of course, the client never knew it, but the Ohio office missed the last FedEx pickup the night before I was due to show them in Hollywood. After frantically searching for any flight or any way in the whole wide world to get them to California, we finally found a puddle jumper that left Columbus, Ohio, in time for me to drive to the Burbank, California airport just in time to make my presentation. We would have most certainly lost this new and important client had I not shown up with my presentation that day.

relaxing, you will learn new things and experience new visuals, sounds and aesthetics—key elements to your ongoing creativity.

Take a minimum of three weeks off annually. That's right, a minimum. Learn to travel, either by foot, bicycle, car, train or plane—just learn it. Experiencing things on foot can be a real surprise. The scenery goes by much slower, and it's a great way to experience how different seasons of the year affect the light outdoors, among other treats nature has to offer. I am not going to make this a lecture on nature or spending money you don't have to do things you can't afford. You simply must allow yourself time away if you are going to be successful long-term.

Guilting yourself into believing that you don't have time to take a break or the kids need you more or the leaves need to be raked and the garage cleaned out is a very unhealthy approach to your own well-being. Clients understand vacation time; they take every bit they can get. And your kids either need a break *from* you or *with* you—so do it!

Make sure you tell your clients—even those with whom you don't have an active project going—that you are taking some time off to regroup. If you take on a project that falls within your vacation time, notify your client up front that you will be out during such and such a time, but you see no problem in fulfilling the project in a timely fashion by doing x, y and z. Have a ready solution in your pocket, and you will all be the happier for it. The worst thing you can do is make a commitment to take a break and then disappoint yourself or others by backing out. If this happens, you are the only one to blame—so don't let it!

112

Chapter 8

Negotiating, Pricing and Billing

Don't ever let yourself become intimidated into second-guessing yourself—or your client. Countless times I have coached students and young freelancers to stand up for what they feel is fair, not only regarding pricing structure, but also creative applications on assignments. Many clients can seem overbearing and controlling, especially when a relationship is new. Ultimately, being direct and straightforward and asking for exactly what you want will gain you more respect.

Being a Winner at Negotiating

Knowing exactly how to ask for what you want is much simpler than it may seem. For now, let's stick to the concept of asking for what you want regarding creativity and process on your projects, and later in this chapter I'll discuss establishing rates. First, sit down with a blank notepad and write down the ideal job process for yourself. See the list below for some guidance on the types of questions to ask yourself.

Five Questions to Help You Learn What You Want

1. Do you want art direction from the client or are you confident in your own art direction capabilities?

2. Do you write good copy, or will you want copy to come from your client?

3. Will you want the client's assistance in brainstorming creative direction and theming for your projects, or will you want to provide these services on your own?

4. Will your first presentation to the client be very rough (in the form of loose pencil drawings) or tight and comprehensively executed (finished looking)?

5. Will you be presenting to only one person or several? At your office/studio or at the client's office?

Knowing the answers to these five questions is very important in refining your negotiation tactics. You may find that as your business grows the answers to these questions will change and evolve. You may also find that the answers may be different for different clients. In some cases, you might be sharing this list of questions with your client, answering them together.

My point in your providing the answers to yourself first is for you to establish your priorities. For example, if you are absolutely certain that you are not capable of taking art direction from a client, you will know right away that a project is going to cause you grief if a client insists on creative control.

Let the Negotiations Begin

For a case in which a client will make color choices or photography vs. illustration decisions, you might ask to be given permission to present your concepts and selections first, as a fresh plate, so to speak. Or you might be sensitive to your client's needs and make a fun session out of deciding together, before you get started. There are many different ways this process can—and will—evolve. In my experience, being absolutely certain of your own needs and barriers, along with a genuine familiarity of areas in which you are (and are not) willing to be flexible, will help you to communicate and get what you want in the long run.

It is important, furthermore, that you take my short list of questions and think about situations that affect your individual communi-

cation capabilities. Negotiating for success is all about knowing your strengths and acknowledging your weaknesses. Now is the time, when it's just you and that pad of paper, to write down everything that you know about yourself from a communications standpoint. Do you speak without thinking? Do you have a hard time reacting spontaneously to situations? Are you a good listener? Do you draw a blank when someone asks you a question you are not sure of?

Prepare yourself now for the unknown. By acknowledging your weaknesses you can be ready for the inevitable. If you have a hard time thinking on your feet, know that you will need to tell your client that you need to think about the particular subject matter and that you will get back to him promptly. No one will look poorly upon you for asking for what you want. You will be respected for knowing what you need to be more effective.

The Win-Win Philosophy

Throughout my years of self-employment I have negotiated through countless types of situations. Looking back through my little time machine, I see myself struggling through issues that I felt strongly about, feeling as though I were at combat sometimes with clients whom I sincerely cared about. The stomach churning, the aggravation of wanting my own way—only to be confronted by someone who wanted *their* own way— seemed like something I would always have to grin and bear. Only recently have I discov-

114

ered a new approach that is quite painless.

The win-win philosophy brings the client and you together in a partnership to resolution. I realize now that it took more than fifteen years of being in the business for me to obtain the self-confidence to actually involve clients in somewhat precarious situations in which results are unpredictable. The difference for me now is that I am willing to take the risk—the risk of giving in to the client's demands, the risk of losing some money, the risk of angering the client and even the risk of losing the client. I wish now that I had implemented this approach long ago.

Basically, the approach revolves around one philosophy—complete and total honesty. Combined with a willingness to be very open to the client's input and criticism, the risks of being completely honest have paid off many more times than they have failed.

An example is the Lexis-Nexis binder project shown on page 117. The client is promoting news/information software that is very fun, easy and cost-effective to use. Prior software distributed by the client was difficult to use and expensive. Our client was a marketing product manager with little or no design background. When we presented our initial concepts and budget, the client's purchasing department decided that our budget was too high. Eliminating the ground-newspaper chipboard material for the binder and envelope packs would bring the cost down dramatically.

Instead of simply following orders, we embraced the budget problem head-on by reviewing the original objectives of the project. Yes, the binder stock was expensive; however, it visually answered many issues—it was obviously a recycled stock, and the company had a problem of appearing too "slick" with its

other promotional pieces. The stock immediately sends a connotation of being "fun" since it is confetti-like in appearance. It was also more durable than a money-saving alternative suggested by the purchasing department. Our client was caught between the demands of his budget and his desire to use the stock we were recommending.

We were completely honest with the client, sharing printing and paper costs, itemizing future cost savings if the client chose to buy reprints himself to save our markup fees. We also researched and offered other cost-saving samples that did not fulfill design objectives but were money saving. Also discussed was the process of scanning the flecked stock and printing its image on a cheaper stock.

The end result was win-win. We used the originally recommended stock. The client was able to change delivery demands so the bindery could have more time in the manufacturing process, thus reducing their costs. We gave the client permission to handle reprints themselves to save our markup fees on future runs. The entire process took several meetings and some give-and-take from both parties. The end result was a multiple award-winning piece for us and a happy client. Our "loss" was future markup costs of 15 percent on some pretty nice-sized runs. Our "gain" was more trust from the client, which resulted in more projects with that particular division.

Providing win-win solutions is very rewarding. It almost always results in more work or higher accolades for your performance. It shows your client that you care about more than simply getting your way. It also shows a desire for longevity in your relationship with the client and a commitment to being a real businessperson.

115

Comparing Apples to Apples

Make certain when you are negotiating through touchy situations that both you and your client are comparing apples to apples. In the Lexis-Nexis situation, the purchasing person was simply doing his job—cutting the budget. The stock alternative he was recommending, however, was not in any way the same quality—visually or from a printability standpoint. It was important for us to educate the client and provide printed samples along with our quest for fulfilling communication objectives through design, in this case using the paper as an important design element.

Many times clients will try to compare your work to work from other freelancers or even design firms or agencies. It is important for you to enlighten them on how your skills or services differ from those you are being compared to. I endeavor to make analogies pertaining to my clients' areas of expertise so they might better understand my situation.

For example, the owner of a popular restaurant in town had us design labels for a line of salad dressings he had developed for commercial distribution. He loved the labels so much that when he saw the final artwork he decided to increase the quantity of the printing run. When the restaurant manager saw them, he did not like them and was angry that his boss had assigned the project without his input. The boss informed me we would not be paid. My analogy to him was, "Suppose I brought in fifty friends to your restaurant for a dinner party. We have a great time. We marvel about the food. We clean our plates.

Then, we refuse to pay the bill—get the picture?" He did.

Putting yourself in your client's shoes when there is a troubling situation to resolve will help both of you come to a quicker and more amicable solution.

Making the Client Feel Good

If you don't care about how your client feels and you have no intention of studying some behavioral issues that will make you a better negotiator, then you had better not be a freelancer! Negotiating successfully doesn't mean that you won't get your way, and it doesn't mean that you need to keep a scorecard showing who has given and taken what. Ultimately, it's the *manner* in which you go about your negotiating that really matters.

When you get really good at this, you'll win a lot of your battles by having the client think that the resolutions were her idea and that she is actually getting her way. Asking the client for input and putting her insight to work effectively for your own benefit will make you a hero. Use comments such as "That's a great idea" and then go on to expand on your own version. This shows that you can share ownership of the client's perspectives on the matter, yet it allows you to move on to your own ideas.

I know that sometimes it seems wearisome to think about how the client feels when you have your own feelings and issues at hand. My advice is that if you are weary, then you are not being totally honest with your client. Open

Lexis-Nexis software library binder, mailing envelope for diskette holder and small accompanying advertising brochures. This project is a perfect example of negotiating a win-win solution. The client was initially concerned that the budget for the project was too high and wanted to eliminate the ground-newspaper chipboard material used for the binder and envelope packs. In reviewing the project objectives, we were convinced that this stock was a good choice. By researching and presenting our client with other alternatives, however, we were more convincing than we would have been if we hadn't known—and presented to our client—all viable options.

TEN NO-FAIL NEGOTIATING TIPS

1. Listen to your client's needs first; encourage him to be thorough.

2. Make eye contact and validate your client by nodding your head or by saying "I understand." Remember, you can understand the client's story without necessarily agreeing with it.

3. Do not sigh or take deep breaths at any time. Be mindful of your body language. Smile if you can!

4. Be interested; take notes.

5. After your client is finished, briefly review objectives of the piece or issues in question.

6. If you need time to respond, ask for it. Don't respond spontaneously unless you are absolutely certain of the direction you wish to take.

7. When you do make your response, review any positive messages first. If you readily agree to anything your client said tell her so. Begin by saying something like "I'm really confident we can work this out" or "I am really relieved that this situation will be resolved."

8. If you are going to present something that is in direct opposition to what your client has proposed, begin by saying something like "I understand your position to be _____." Repeat the client's words from your notes so you prove your understanding.

9. Follow with something like "In reviewing the objectives, I think it is important for us to also note _____." The key here is that you are *adding* to the client's comments, not undermining them.

10. Never raise your voice or get emotional about your work while negotiating. You must remain objective or you will lose not only your client but your sanity. There is always the next job that you will fly through and in which everything *will* go your way.

up and take the risk. You will be rewarded well with respect from your client.

Establishing Rates

There are basically three ways to price your services: (1) copycatting other freelancers' rates by taking a poll, (2) using an algebraic formula and (3) using what I call the "value" system. My favorites are the algebraic formula and the value system; I use a combination of both for my firm now. Don't let the word *algebra* scare you. Quite honestly, I had to take college algebra twice (you know what that means!), but this formula is very simple and effective.

Do Some Sleuthing

You can discover what other freelancers charge for their services by asking them. You probably have a local chapter of the AIGA or similar group that meets monthly. If you are not a member, join immediately to learn more about your chosen industry, be inspired by well-respected monthly speakers, meet your local peers and enter their annual design show.

Introduce yourself to other freelancers, and use the honesty policy if you're just starting out. Admit your newness to the industry and ask for some mentoring. You probably won't want to do this the first time you meet a colleague, but you will find people in the industry generally very friendly and helpful. Ad agencies are also excellent sources for sharing what and how they pay freelance help.

The Algebraic Formula: $a + b = c$

The algebraic formula simply involves listing every bit of overhead you have. Examples of this are:

- A proportionate amount (relative to the amount of space you use) of your rent or mortgage payment if you are working from home, or your studio rent amount if you are leasing
- Your monthly payment for computer equipment
- A portion of your car payment (usually 50 percent if you drive for business half the time)
- Any fixed monthly costs you incur to operate your freelance business

Add these amounts together, divide by the number of hours worked per month (40 hours per week \times 4 weeks per month = 160 hours).

For example, if your studio rent is $450/month, half your car payment is $150/month, computer equipment is $150/month and other costs total $500/month, your total monthly cost of doing business is $1,250. Divide that by 160 hours of work and you get $7.81/hour. This is what you need to make, working 40 hours per week, just to cover your *business* expenses.

Now add in all your actual costs of living, such as the remainder of the rent, food for you (don't forget the dog!), the rest of your car payment and miscellaneous payments. Divide your new total by 160. Can you charge that much per hour? If your hourly rate seems low, good for you! It will be much easier for you to succeed because you won't be pressured to actually "bill" a 40-hour week. Quite honestly, a 40-hour week is very rare. When you have work, you will more than likely work 60-hour weeks with some 10-hour and even 0-hour weeks! Don't worry—it all averages out.

Examine the Value

The "value" system means simply billing a job for what it is worth—to you and your client. For example, if you were to receive an annual report assignment from a multimillion-dollar company, you would expect to receive a higher fee than you would for designing an annual report for a nonprofit group, such as your local art museum. Ask yourself, Is the project good for my portfolio? Am I too busy to be able to afford taking such a low fee? Or, Am I not busy at all and need the money?

Another valuation method is to use your client's budget; many times it will certainly suffice and may even exceed your expectations. If a client says he has $2,000 for a project that you know will take you thirty to forty hours to complete, go for it! You will be surprised how many situations such as this will arise. I prefer to ask clients for their budgets; some clients won't share this information with you—hoping to save money by having you quote on the project, no doubt.

The value method most commonly opens the door for negotiations. Many times your client will need to be educated as to what your services are worth. Small business owners

119

Curtis Parker
On Being a Freelancer

After graduating from Arizona State University, Curtis Parker was hired as a graphic designer for a small design studio in Phoenix. He started his own design studio after three years and after several more years began painting full time. Ten years later he is still a freelance illustrator with agent representation in Ohio and Arizona.

1. What issue do you find yourself negotiating the heaviest for in your freelance business?

Money is always the toughest issue to negotiate these days. The budgets seemed to be getting a little smaller in the last few years. I don't know what the reasons are; there are probably a lot of mitigating circumstances. Creative freedom is a very tough issue to negotiate, and sometimes it's not negotiable. From the very beginning, if you have an art director with a certain idea of how something should be done, and you don't agree, either try to change his or her mind or negotiate a happy medium. Try to find out about the job and its boundaries before taking it. Then you have a choice to take or decline the job. Sometimes you can be negotiating and your visuals will help prove your point. That's about the best way to negotiate on the creativity.

2. You owned a design studio and then sold your share in the business to focus on illustration. What have you learned regarding negotiating in general?

When I sold my business, in terms of negotiating, one of the key things I learned was creativity in the process itself. For example, you get in a position when you're negotiating for the budget, like I was mentioning earlier, and you come to an impasse where the budget is set. The buyer isn't going to pay another dollar and you don't think it's enough. A lot of times there are other things that can make up for that. Think in terms of what else you can negotiate for to make up for the money, whether it is more creative freedom or something maybe non-related to the job.

3. Can you share a special technique that you use in negotiating?

Here's an example: One time I did some work for a golf resort with a fixed budget, and we were negotiating the project. I'm an avid golfer, so I was able to negotiate a whole bunch of passes to be able to golf at their resort. A lot of clients don't mind making those sorts of trade-offs, but they seldom think about offering them. Try negotiating time frames, too. Get your deadline extended when you know they're not paying you enough money.

4. How did you establish your rates?

I signed on with artist's reps, and they are all business. Eighteen to twenty artists are represented by one guy, so he has a pretty good feel for the pricing structure. A lot of times it's supply and demand. But the Graphic Artists Guild has put out a book of guidelines that has been very indispensable to the industry. Following those guidelines has been very healthy in the last two years. The rates have gone down a little bit, and budgets aren't there like they used to be in the past. At the beginning you have to establish yourself with lower rates. When you start out you take the jobs you feel are really good.

You do them for a modest fee to get your foot in the door, to get images in your book so you can negotiate higher and higher fees. I have two reps, one in Phoenix and one in the Midwest. One mainly handles the local business area and the other takes care of national business.

5. Have you ever had to deal with a client you've been doing business with for years and one day realize you're not charging enough?
That is probably the most difficult situation, having an ongoing client that you've been working with for years. I have a client I've been working with for eight or ten years, and my rates have gone up almost indiscernibly with them. It's because they've had a fixed rate, although I did get them to raise my rates one time. Another aspect regarding rates is what used to take me a week when I first started, now takes a couple of days and that gives you a rate raise. You'll gain more confidence the longer you're in the industry. I paint faster than I used to paint.

6. Do you think that establishing a line of credit is a good idea for a freelance designer or illustrator?
I have definitely done it. Lines of credit are good because they're a no-hassle way of getting your monthly cash flow. There are some months when there is just no cash flow and then some months it all comes in at one time. You can't predict it. It's so easy when you have slow times and you start to use your line of credit. But, you can get yourself in debt so fast; it's kind of a two-

edged sword. On one hand it's good to have for those lean months, but on the other hand, if you can't handle having access to it without spending it on unnecessary things, maybe you should reconsider. You have to watch out you don't get in debt really fast. As a freelancer, you need to be able to get a line of credit. You're not seen as having very stable employment by credit industries, and when you go buy a house or a car you're almost looked at like you don't have a job. When you're doing year-end taxes, you want deductions and other tax-saving items if you have a good year. But the same information supplied to the government for tax purposes can make you look bad when applying for credit. You almost have to go into a lending institution to get credit with double the resources of somebody who works at the phone company.

7. What is your methodology regarding invoicing?
My rep does about 90 percent of my invoicing. I send the invoice myself for jobs I produce directly (without my agent). I bill the day after I finish a job because a lot of clients pay thirty to forty-five days after invoice. The longer you postpone it, the harder it is to collect. When my rep does the invoicing I get paid by him.

8. Give us some advice about choosing an agent.
The most crucial thing in the world if you are a freelance artist and wanting to deal with a rep is getting someone reputable. I was involved with a rep who left town with over $5,000 of my money. Finding someone

reputable was as big a concern as how many doors he could get me into, how ethical he was, what kind of person he was and how easy he was to work with. I found a gold mine in Scott Hull. I chose him after calling the artists he worked with and asking them the key things: how his billing schedule is and how soon the artists get paid on projects.

Other key things to look for in a rep are what kind of talent the other artists they represent have, where they are located and what kind of promotion they believe in. You also have to look at the exclusive rights. You have to be careful not to give a rep every exclusive situation. By this I mean that by having two reps, when one is a bit slow, the other seems to kick it, and it balances out very nicely. Right now I'm in a very informal contract with my reps, although there is a no-compete agreement with their client base. I'm more of a handshake-and-deal kind of guy, even though we do have a signed contract.

There are several reasons why having a rep is beneficial. A rep is good for negotiating. In some situations, one of the biggest keys to negotiating is having a third party do it. You can feel self-conscious about negotiating for your own work. When there is a third party, they can tell the client all the good things about your work, how valuable it is and what a valuable person you are. They say all that stuff you would never say about yourself. Another reason to have a rep is it will keep you from getting locked into too severe a deadline and too low prices.

121

especially need to be enlightened that it doesn't just take an hour for you to put together a logo. Significant research and your expertise go into such an assignment, and your client will use this design for years to come. Certainly it cannot be billed on an hourly basis—unless you decide that it has value for your career in some way.

All of the aforementioned negotiating skills also apply to negotiating your rates and any budget issues that arise. Let me put a plug in for my other North Light book, *Pricing, Estimating and Budgeting*. This book details the many variables of establishing pricing and explains how to provide estimates and successfully budget clients' projects.

Raising Your Rates

Eventually the inevitable will happen. You will grow, and the caliber of your work will increase, as will demands for your services. Your work will be recognized, and your name will become synonymous with "a good freelancer." You will need to move to a larger studio, buy more equipment, hire an assistant or become more selective about the type of work you do. You will need to raise your rates.

When this happens, I suggest that your new rate be used for new clients only. If you simply must raise your rates across the board, explain to your clients individually (not via a mass mailing, no matter how clever!) why your rates are going up and how sensitive you want to be to their needs. Negotiate a win-win situation—you know how to do this now! You

will find that most clients, especially clients who appreciate your services, will have no problem with your new rate structure as long as you are up-front and open about it.

Don't surprise your clients by simply announcing your new rate in your next invoice. If you generally charge $500 for a spot illustration, do not suddenly charge them $600 without explanation. No one likes a surprise like this, and it will be deemed unprofessional on your part. Also, don't make apologies for your new rate—you deserve it! If you are raising your rates more often than once every eighteen months or so, something is wrong.

Establishing Credit

Bankers can be your freelance business's most valuable asset (no pun intended). Just remember that they focus on one thing and one thing only—your bottom line. Banks have really grown in the services they provide, especially to self-employed people. With the twenty-first century looming at our doors, the outlook for self-employed, cottage industry businesses has never been stronger. The financial industry is definitely evolving with the growing number of successful entrepreneurs.

Larger financial institutions have services called "private" bankers or "personal" bankers. Contact the small business division of your bank to inquire about services pertinent to your needs. Do not feel intimidated to discuss money issues with an expert. That is what they are there for, just like freelancing is what you are there for. It is their business to find ways to help you.

The financial services most likely to be avail-

124

125

FRANCHISING WITHOUT THE FRENCH FRIES

Think about running your business like a franchise operation. By this I mean that you should develop consistencies that you and your client can become familiar with. Take a few hours at your local library to study some successful franchise case studies. Also, review some of Thomas J. Peters's *In Search of Excellence* materials or videos. You will glean invaluable information from this short study that you can adapt to your own business. Some things to look for and implement:

- Areas of your business in which you can offer absolute consistencies, such as establishing flat prices for spot art that clients can rely on your charging every time they hire you.

- A consistent, cohesive invoice and paperwork method. Establish a format that your clients will become familiar with.
- A consistent scheduling methodology for your projects.
- A consistent format for how you (and your kids or others sharing your space) answer the phone.
- A consistent presentation method (mounting your projects on boards, putting them in a folder, putting them in an acetate sleeve, etc.).

Developing these consistencies will give your clients (and you) a comfort level with what to expect, when and how. It shows that you are truly "in business" and in for the long term, dedicated to continuity and clarity of communication.

able to freelancers starting out are free checking, overdraft protection and a credit card to cover overdrafts and business needs. Many of these programs have special incentives attached.

Ask about special programs offering business loans, especially if you are a woman, disabled or a minority of any type. There are special federal loan programs that you may qualify for. Be prepared for lots of paperwork and signing on the dotted line! In other words, be prepared to be committed to the success of your business. These programs are monitored with your cooperation and good record keeping.

The Relief of Credit

A line of credit (LOC) can provide great relief to your cash-flow needs. Usually a line of

credit is given for about 80 percent of the average of your total monthly invoices. If you bill $4,000 per month in gross fees, typically a bank would lend you $3,200 to use in a "revolving" method, a line of credit. This type of loan is not a handout that you spend right away and then make payments on as you would a car payment.

A line of credit is used in a give-and-take method. For example, if you have a bill for $500 that is due the first of the month, you use $500 from your LOC. Three days later, you receive a check in the mail for $650. You pay $500 back to your LOC and keep $150 for yourself. Use the LOC as a temporary cash-flow reliever so you can pay bills on time while collecting your fees. Pay back your LOC right away, since you will be charged a monthly interest fee for the days you are carrying a

balance. Your banker can explain specific LOC procedures to you. Never, never use your LOC for things such as equipment or vacations. You only want to use it to pay bills that will keep your business flowing smoothly. The last thing you need is to have bill collectors calling you or to carry an LOC balance that you can't pay back because you used it for the wrong reasons.

Beyond the special federal programs, lines of credit are available to more-established free-lancers who can show a track record of established billables, consistent clients and income. Lines of credit are also available to people who have equity in any number of different types of assets. A home, a boat, fine art and appraised valuables are just some of the assets banks will consider as collateral when lending you money.

If you have no real assets, develop a solid relationship with a private or personal banker by sending them a copy of your monthly invoice log and showing them your profitability. Offer to take them to lunch and ask specifically what you need to provide them with to qualify for the types of services you are interested in.

Banks also offer other types of loans and lease programs for equipment and other long-term business growth such as staffing, studio space, etc. These are usually called "capital" loans and are set up so you can make comfortable, monthly payments.

When I started my freelance business, my financial needs were relatively bare-bones. I was not married and had no children to support. I sold my car and paid cash for an older car. I had no credit card debt. I was paranoid about the amount of money I could or would make. Four months later I bought a new car and felt a little more comfortable with how my work flow was going to be. But I started freelancing before computers were an absolute

must in the designer's studio. It is fairly inconceivable to be a freelancer long-term without owning equipment that will aid your process—and many times this equipment is quite costly, needing annual upgrades.

Obtaining an LOC or capital loan can help your business grow by giving you peace of mind to focus on what you do best. Making your monthly payments on time will increase your self-confidence and professional integrity within your community. Having your own equipment will make you more efficient, and thus able to take in more work, which will result in higher billables. A domino effect of growth can be yours if you manage your finances with the help of a good banking relationship.

I said earlier to never forget that a banker's main interest is your bottom line. Ask how your banker wants to receive reports on your business, the preferred format, etc. Follow the banker's instructions closely so he can easily understand your business activities. If the banker does not have confidence in your business right away, keep persevering by following through with memos on new client contracts and monthly financial information. This discipline will be good for you and keep you motivated to keep good records and keep getting out there, selling your services.

Do not hesitate to show prospective bankers your portfolio, not necessarily as a potential client, but to educate them on the types of clients you serve and the unique skill set you have to offer. Your banker could be an excellent source of new business referrals. Just as you are a small business customer, your banker probably services forty to fifty other small businesses, several of which might be able to use your services!

Educating bankers about your freelance

capabilities will show them that you have business savvy, you have a credible client list, your pro bono work is important to the community, etc. If you treat your banker respectfully and with thoroughness, you will soon obtain the financial assistance your business requires. There may be financial or small business consultants or mentors through your local chamber of commerce who can help you prepare your business documentation for prospective bankers.

Billing—The Really Fun Part

When you acquire new clients, research them until you find a comfort level with their business expertise, specifically how they pay their bills. Call your local Better Business Bureau or ombudsman's office to determine what types of complaints have been filed about them. For small business clients, you might want to ask for credit references.

This can be awkward if you are not working directly with the business owner. However, every small business is asked to provide proof of creditworthiness at some point. A prospective client who is offended by your inquiry probably has something to hide. Make it easy for yourself and your client. Create a simple form with your business name/logo and spaces for the client contact name and position within the company, several credit references (vendors with whom the client has a track record) and the client's bank. Then provide a space for the contact person's signature acting as a responsible party. Ask your tax accountant or

attorney for a typical copy of one of these credit forms. You have probably filled them out yourself a time or two.

If your clients are Fortune 500 types, or large established businesses, you probably won't need to worry about good credit. Ask your client if you can expect your bills to be paid within your terms, whether it is within a week, which is typical for some freelancers, or within thirty days, which is more likely.

Invoicing really should be a fun part of your day, and note that I said day, not week or month. You should invoice your work just as soon as a project is done. This will dramatically improve your cash flow. If you do your invoicing weekly, or even monthly, expect to have long, cashless lapses.

When your work contract or agreement is signed by your client, make your payment terms very clear within that document. It is common for agencies to pay their freelancers on a weekly basis for long-term, ongoing projects. It is also common for corporate projects to be billed 50 percent upon project initiation and the final 50 percent upon completion.

There are countless types of invoices, from the preprinted variety at office supply stores to a simple invoice you create on your letterhead. My firm still uses a simple format that we print on our letterhead. Many accounting programs and job tracking programs include invoice formats. Use a format that is easy for you to complete and easy for your client to comprehend.

Involve your client with your payment needs the very day you agree to contractual terms. Ask him what you can expect and who your contact should be if you have problems receiving payment in a timely fashion. Many times your client will give you the name of an accounts payable person. Get all questions

127

This "Suddenly" series of ads for Cub Foods has a central "timing" theme, and the ads themselves are also an example of good planning, including a good use of time. The ads were somewhat expensive to produce, being small sheet-fed ads in a world where newsprint web ads are usually king. We produced and printed all three of the ads ahead of schedule so they could run together, thus making the series affordable to the client.

and concerns about payment issues out of the way before you begin a project.

When and if you do have a problem getting paid in the way you and your client agreed to, do not hesitate to bring the matter to the appropriate person's attention immediately. It is wonderful if you have someone who can handle your collections for you. Asking for payment, especially from the actual client who hands you your creative project, can be rather awkward.

Many times creative people have a difficult time communicating about money that is owed them. If you know this about yourself, ask your accountant or lawyer if he can provide these services for a nominal fee or if he knows someone who would help. Someone close to you—a sibling, parent or friend—also might act as your bookkeeper to clients, inquiring on your behalf about payment.

If a client promises payment that is past due, send a memo (or have your bookkeeper/collector do so) on your letterhead, detailing the agreed-to payment action. Simply thank the client for her attention to the matter and tell her you appreciate her acknowledging during such-and-such phone conversation on said date the amount of said invoice and when it would be paid. Follow through the very day after she said your payment would be received if you have not gotten it yet.

If you still have problems, you may consider talking directly to your creative contact and/ or withholding additional services until you are paid. This is an extreme measure, usually indicating a definite problem and a low probability of relationship longevity. Your last resort is to hire an attorney, after you have exhausted all of your own communication skills and ability to wait. You should not wait more than sixty days from a promised payment date to take more serious action.

In my fourteen years of self-employment I have had to hire a collection attorney only one time. On one occasion I took a client to small-claims court because the amount owed me was small enough ($3,000 or less in the state of Ohio—check your local court's office, as this amount may vary, and is always updated) to file the claim with the courts myself, saving attorney fees.

This is not to say that all of my clients pay me within my invoice terms, even though we have an agreement. I have a strict policy that if a client is five days past the thirty-day invoice date, my office manager calls the appropriate party to make arrangements. You will find that many businesses, large and small, will take their good old time making payments unless you call and ask for your money. Many companies don't even issue checks until they are telephoned. Don't take this personally—just know which clients have what habits and mark your calendar appropriately! You have earned your fees and should not be embarrassed or apologetic to ask for them.

Chapter 9

The Law and You

One of the saddest things I have witnessed throughout my years of entrepreneurship is that too many people who want to freelance either don't do it, or if they do they don't succeed, for one reason: They are intimidated by the nitty-gritty business procedures. Maintaining proper records for your business needs starts with one very simple (yes, simple!) task—hiring the right accountant.

Hiring an accountant does not have to cost a lot of money. In fact, it will probably save you money sooner than later. The first year I freelanced, come tax time I skipped happily to my boyfriend's tax accountant. I did *not* skip home. I cried for days. I had not prepared my records or my bank account for the outcome. I was lucky enough to get a helping hand from my mother, and I spent the better part of the next four months paying her back.

The IRS Can Be Your Friend

A good accountant is one with whom you are very comfortable discussing money issues. This is difficult for some people. Stereotypically, creative people have a hard time discussing and managing money—even more reason for you to have a good accountant. Use your networking skills to find an accountant. He does not necessarily have to be a CPA; a tax accountant will certainly suffice. He will save you money and specializes in what you need—tax savings. I used a tax accountant the entire time I was a freelancer and for several years after starting my design firm with great success.

Your tax accountant should already be providing services for someone in the creative field. That way, he will have brushed up on all the possible tax incentives that you might qualify for. He will also be able to help you plan and budget for the following year. A tax accountant will also charge much less than

a CPA because he specializes in tax accounting rather than complex corporate accounting procedures that you don't need anyway.

Put yourself in the driver's seat when looking for an accountant. You will do best going into the relationship for the long term. The longer your accountant works with you, the more familiar he will become with your spending habits, your organizational skills in regard to fiscal issues and suggestions he might make to your benefit. He will also be able to recommend "systems" for you to implement, perhaps forms you can use to simplify the process of getting him information so he can, in turn, help you be friends with the IRS.

The biggest favor you will do for yourself in getting organized for your accountant is to set up a log system for individual jobs. We discussed this earlier as a mechanism for studio organization. Now, add to your log system every expense that you incur on a project—every invoice you receive that should be applied to the cost of producing the project—including such things as courier charges, overnight delivery, transparencies that needed to be scanned, etc. These charges really add up. Next, develop a way to categorize these external expenses after a job is finished and you have billed it. Use the list below to get you started.

Project Expenses and Tax Deductions

Have a folder for each of the categories below. You will probably create more categories pertinent to the type of work that you do. This is just a simple list to get you started.

- Freight, including couriers, postage and overnight delivery

- Outside creative fees you might have incurred to finish the job, including your use of other freelancers (photography fees, copywriting, illustrations, etc.)
- Scans and color separations
- Laser copies, black-and-white or color
- Printing

Set up a record-keeping method that is simple and doesn't bog you down with tasks that turn you into a full-time administrative assistant. Ask your accountant how she wants to receive your information. Many accountants will walk you through an easy process, step by step. I have found that the best accountants are patient and forthcoming with assistance when you are in the set-up phase of your freelance business. Every time I have had to hire the services of an accountant, I have spoken to three of them before I have decided which one to use. One of the three always stands out as a good, patient communicator to my left-brained soul!

There are many tax benefits to having your own business, not to be confused with taking advantage of the tax system. In these wonderful technical times of ours it is very unwise to not be totally honest with the IRS; however, there is nothing wrong with being creative. Let your accountant give you hints and lists of things that you will be able to deduct from your tax bill. Know that on the average one of every five tax returns (which are not classified in the poverty category) are audited every year. If you do have the good fortune of being chosen for an audit, having a good accountant to sit through the process with you will certainly help, as will her signature on your tax documents as the preparer.

Being a freelancer does entitle you to write off things such as your car lease, a portion

of your home mortgage or rent (if your studio is in your home) and reference books and magazines you subscribe to. However, very careful documentation and receipts for these expenses are necessary for you to keep. Keeping records by category, as described previously, is best.

What a Lot of Freelancers Learn the Hard Way

Every quarter your accountant will probably need to refer to your categories of expenses, compare them to your income and file a quarterly tax return with the IRS. This process will save you from severe headaches at the end of the year and also, quite possibly, penalties in the form of hard-earned cash. The crying I mentioned after doing my first freelance year's tax return revolved around the fact that I didn't have a clue about the necessity of quarterly returns.

Your accountant can help you prepare for this process. Don't be alarmed about it. It is a huge relief to process tax payments every three months—really. It is a huge nightmare to find out that you are being penalized because you actually made some money freelancing but you didn't share the proper amount with Uncle Sam.

Also, don't worry about how much your tax accountant will charge to provide these services. Just ask her. Perhaps you can make arrangements to pay on a monthly basis, stretching out your payment for quarterly and annual tax return preparation fees, along with some cash-flow or growth planning. Your accountant can be your very best ally when it comes to profitability. Go ahead and invest in yourself. Now is the time to spend a little money to make a lot of money—legally!

Real Art uses this rubber stamp on *every* presentation board that goes out of the office. You can make one for yourself for about $9; it will add professionalism to your work and show your knowledge of your rights as an artist.

How to Protect Yourself and Your Art

My advice for protecting your most valuable asset—your artwork—is the same as for hiring an accountant: Keep it simple. Protecting your work can seem as daunting a task as playing undercover agent or TV lawyer. Don't overdo it. The basic streetwise way to go about the best protection is to have a good, easy-to-use, easy-to-comprehend contract.

A comprehensive contract does not have to be multiple pages. It should include the parameters of the services you are providing, what your responsibilities are, what the client's responsibilities are, the usage rights you will give the client and the terms in which you expect to be paid.

132

THE FIVE MOST IMPORTANT THINGS THE IRS WILL WANT YOU TO KEEP TRACK OF

1. Your business mileage incurred on your auto vs. the total mileage you drive for personal use. This can be a royal pain but it is the most important element that will add up to real savings if you document it properly. Use your calendar every day to record mileage next to the appointment location and theme of your meeting. The IRS is very picky about this documentation.

2. Interest charges on any business loans for equipment, mortgage, etc.

3. All expenses categorized by type, as described earlier in this chapter. If you use photographers, copywriters, illustrators, etc., to complement your work, in order to write off their fees you must obtain their social security or federal ID number so you can send them a 1099 form at the end of the tax year. Again, ask your accountant for the details.

4. Costs of new equipment, office furniture, automobiles—any large purchases that your accountant will depreciate. Depreciation means you may not get to write off 100 percent of the item the first year you buy it, but you will get an ongoing tax deduction for it. Ask your accountant for the latest and greatest IRS rules. There are some nice tax incentives for freelancers buying lesser amounts of large goods than the "big guys."

5. Phone bills and utility bills necessary for you to conduct business. This includes any Internet providers, gas, electricity, water, etc.

You should not need the services of an attorney on an ongoing basis, but you should spend a few hundred dollars with an attorney who will give you the basic shell of a contract and show you how to revise it as needed.

Again, as with the accountant, use your networking skills to seek advice on an attorney who is used by peers or colleagues, one who is familiar with industry jargon. Request a meeting for consultation regarding the preparation of your contract, and ask if you should expect to be charged for the initial consultation. Ask what the fees will be to prepare such a document. You might get a comfort level over the telephone with an attorney who knows exactly what you want. Rates can be $85–$350/hour. Don't be intimidated by the fact that you are talking to a lawyer. After all, some of us have been to school as many years

as they have, and eventually your hourly rate will be close to (or even more than!) theirs.

Copyright Law

The basics of copyright law are covered very thoroughly in my interview with Mark Levy. I strongly suggest that you take his advice of using ©, the year the work was created and your name or studio name. This immediately shows the world that the work is indeed yours. Whether you pursue copyright registration depends on several considerations. Is your work something you might want to use again in another situation? Is your work significant enough in content that its unique nature should

Mark Levy
On Knowing Your Rights

Mark Levy specializes in copyright law at Thompson, Hine & Flory in Dayton, Ohio. The firm has an Internet site at http://www.thf.com. Mark can be reached for professional consultation at 2000 Courthouse Plaza NE, P.O. Box 8801, Dayton, OH 45401, or by calling (937) 443-6949.

1. Give a brief synopsis of copyrights as they pertain to designers and illustrators.
One of the most important things to point out is the difference between copyrights and trademarks, and I'll get into the differences later. These two terms are often misused and misinterpreted by artists and their clients.

An individual artist's copyright is actually a collection of rights—not only a single right. The copyright covers each different usage of the artwork and the right of that work's reproduction. When an artist is paid the value agreed upon for his work, reproduction rights are then transferred to the client for usage. It is extremely important for the artist's contract to be very specific about those reproduction rights and how his work will be used by the client.

Copyright law was recognized by our forefathers as necessary to create protection for creators of intellectual property. Article 1, Section 8 of the U.S. Constitution empowers our Congress to "promote the

progress of science and useful arts by securing for limited times to authors and inventors the exclusive right to their respective writings and discoveries." Artwork is considered "intellectual property."

2. Should designers and illustrators use a © on their work?
Yes. Absolutely. Even though current copyright law automatically protects the creator of original artwork, failure to identify one's work with a ©, followed by the artist's name, or a name by which that artist is recognized, and the year of the artwork's publication may result in making the artwork vulnerable to usage by others who might claim that they had no idea whose artwork they were using.

Follow these examples: © Theo Stephan Williams, 1997, or you could use your studio name: © Real Art Design Group, 1997.

3. What else should designers and illustrators know about copyrights?
When artists are employed with

a salary from an entity, their employers usually own the copyright to the artwork(s) of their employees because the artist, in fact, works for and is paid by the employer. Only in an independent situation such as freelancing or studio ownership does the "creator" of the work "own" the copyright to his work. Another exception could be that a salaried employee might have a negotiated contract stating that he owns the copyrights to his own work, but this is very rare.

The length of the legality of a copyright is the artist's life, plus fifty years. This explains why we see so many great artists' works used legally in new ways, in the public domain, such as Leonardo da Vinci's Mona Lisa.

4. What is the difference between © and ™?
A ™ on artwork means basically nothing for all intents and purposes in regard to legal copyright protection. ™ is used as a symbol generally meaning that the company who is displaying the ™ is doing business

in good faith and that the artwork is something that was created in that good faith to promote that company in some way.

5. What about ®?

An ® after a piece of artwork (usually a logo) means that the owner of the artwork has registered the artwork with the Copyright Office of the Library of Congress. This is done by filing the form shown on page 136 to establish public record of the copyright claim. It is important that this form be completed and submitted in a timely fashion for enhanced credibility should there be an infringement suit.

The form VA (for Visual Arts) may be obtained directly from the Copyright Office (check under U.S. Government listings in your local phone book) and comes with very specific, detailed instructions. The registration procedure itself is relatively simple.

A copyright registration, ®, is theoretically effective on the date that all required elements are received by the Copyright Office. Hundreds of thousands of registration requests are sent annually to the Copyright Office. Applicants will probably receive a certificate of registration within four months of the request submission. Should the application be denied for any reason, a letter will be sent explaining the situation within about four months also.

6. What about trademark infringements? If ™ is relatively meaningless after a piece of artwork, why is it seen so frequently?

™ is not a notice of actual registration with the proper government offices. A trademark (which is usually a symbol, design, work, slogan or a combination of words and graphics that identifies the goods and/or services of a company) must be registered with the U.S. Patent and Trademark Office. A lengthy search is conducted via Patent and Trademark Depository Libraries that are literally like huge rooms filled with shoebox-type containers containing previously registered items.

It is important to reiterate that the owner of a federal trademark registration may give notice of registration by using the ® symbol. If a trademark "owner" does not have the legal federal registration authorization from the U.S. Patent and Trademark Office, he must use a ™, which does not necessarily protect the artwork.

7. Is it the designer's/illustrator's responsibility to educate clients in regard to copyrighting or trademarking a new logo design?

Corporate clients know that in order to protect original works of art they must go through the proper legal channels. Large corporations employ their own legal professionals to follow the proper procedures to protect things like new advertising slogans and corporate identity elements.

A freelance designer will own his own copyrights to his work unless buyout arrangements are made within the artist/client contract. A freelancer would probably never register

a trademark for his client. The client is responsible for protecting his elements of identity.

8. What legal action should a designer or illustrator take when he discovers that a client is using artwork he created and did not pay for?

Many times it is simply a matter of having a very specific contract that includes usage rights to the client *before* the artist provides his services. After that, if an artist finds the client not acting within the parameters of the contract, he should notify the client first to see if there is a misunderstanding and pursue collecting his appropriate fee. If the client refuses to acknowledge the artist's request, a lawsuit should be filed.

135

FORM VA

For a Work of the Visual Arts
UNITED STATES COPYRIGHT OFFICE

REGISTRATION NUMBER

VA VAU

EFFECTIVE DATE OF REGISTRATION

Month Day Year

DO NOT WRITE ABOVE THIS LINE. IF YOU NEED MORE SPACE, USE A SEPARATE CONTINUATION SHEET.

1 TITLE OF THIS WORK ▼ NATURE OF THIS WORK ▼ See instructions

PREVIOUS OR ALTERNATIVE TITLES ▼

PUBLICATION AS A CONTRIBUTION If this work was published as a contribution to a periodical, serial, or collection, give information about the collective work in which the contribution appeared. Title of Collective Work ▼

If published in a periodical or serial give: Volume ▼ Number ▼ Issue Date ▼ On Pages ▼

2 a NAME OF AUTHOR ▼ DATES OF BIRTH AND DEATH
Year Born ▼ Year Died ▼

Was this contribution to the work a "work made for hire"?
☐ Yes
☐ No

AUTHOR'S NATIONALITY OR DOMICILE
Name of Country
OR { Citizen of ▶
 Domiciled in ▶

WAS THIS AUTHOR'S CONTRIBUTION TO THE WORK
Anonymous? ☐ Yes ☐ No
Pseudonymous? ☐ Yes ☐ No
If the answer to either of these questions is "Yes," see detailed instructions.

NOTE
Under the law, the "author" of a "work made for hire" is generally the employer, not the employee (see instructions). For any part of this work that was "made for hire" check "Yes" in the space provided, give the employer (or other person for whom the work was prepared) as "Author" of that part, and leave the space for dates of birth and death blank.

NATURE OF AUTHORSHIP Check appropriate box(es). **See instructions**
☐ 3-Dimensional sculpture ☐ Map ☐ Technical drawing
☐ 2-Dimensional artwork ☐ Photograph ☐ Text
☐ Reproduction of work of art ☐ Jewelry design ☐ Architectural work
☐ Design on sheetlike material

b NAME OF AUTHOR ▼ DATES OF BIRTH AND DEATH
Year Born ▼ Year Died ▼

Was this contribution to the work a "work made for hire"?
☐ Yes
☐ No

AUTHOR'S NATIONALITY OR DOMICILE
Name of Country
OR { Citizen of ▶
 Domiciled in ▶

WAS THIS AUTHOR'S CONTRIBUTION TO THE WORK
Anonymous? ☐ Yes ☐ No
Pseudonymous? ☐ Yes ☐ No
If the answer to either of these questions is "Yes," see detailed instructions.

NATURE OF AUTHORSHIP Check appropriate box(es). **See instructions**
☐ 3-Dimensional sculpture ☐ Map ☐ Technical drawing
☐ 2-Dimensional artwork ☐ Photograph ☐ Text
☐ Reproduction of work of art ☐ Jewelry design ☐ Architectural work
☐ Design on sheetlike material

3 a YEAR IN WHICH CREATION OF THIS WORK WAS COMPLETED This information must be given ◀ Year in all cases.
b DATE AND NATION OF FIRST PUBLICATION OF THIS PARTICULAR WORK Complete this information ONLY if this work has been published. Month ▶ _____ Day ▶ _____ Year ▶ _____ ◀ Nation

4 COPYRIGHT CLAIMANT(S) Name and address must be given even if the claimant is the same as the author given in space 2. ▼

See instructions before completing this space.

TRANSFER If the claimant(s) named here in space 4 is (are) different from the author(s) named in space 2, give a brief statement of how the claimant(s) obtained ownership of the copyright. ▼

APPLICATION RECEIVED

ONE DEPOSIT RECEIVED

TWO DEPOSITS RECEIVED

FUNDS RECEIVED

DO NOT WRITE HERE OFFICE USE ONLY

MORE ON BACK ▶ • Complete all applicable spaces (numbers 5-9) on the reverse side of this page. DO NOT WRITE HERE
• See detailed instructions. • Sign the form at line 8. Page 1 of _____ pages

EXAMINED BY FORM VA

CHECKED BY

☐ CORRESPONDENCE
 Yes

FOR COPYRIGHT OFFICE USE ONLY

... SPACE, USE A SEPARATE CONTINUATION SHEET.

5 ... version of this work, already been made in the Copyright Office?
... (Check appropriate box) ▼
...shed form.
...
... Year of Registration ▼

6 ... 6b for a derivative work; complete only 6b for a compilation.
...ased on or incorporates. ▼

See instructions before completing this space.

b. Material Added to This Work Give a brief, general statement of the material that has been added to this work and in which copyright is claimed. ▼

7 DEPOSIT ACCOUNT If the registration fee is to be charged to a Deposit Account established in the Copyright Office, give name and number of Account.
Name ▼ Account Number ▼

CORRESPONDENCE Give name and address to which correspondence about this application should be sent. Name/Address/Apt/City/State/ZIP ▼

Area Code and Telephone Number ▶

Be sure to give your daytime phone ◀ number

8 CERTIFICATION* I, the undersigned, hereby certify that I am the
check only one ▼
☐ author
☐ other copyright claimant
☐ owner of exclusive right(s)
☐ authorized agent of _____
 Name of author or other copyright claimant, or owner of exclusive right(s) ▲

of the work identified in this application and that the statements made by me in this application are correct to the best of my knowledge.

Typed or printed name and date ▼ If this application gives a date of publication in space 3, do not sign and submit it before that date.
Date▶

☞ Handwritten signature (X) ▼

9 Mail certificate to:
Name ▼

Certificate will be mailed in window envelope
Number/Street/Apt ▼

City/State/ZIP ▼

YOU MUST:
• Complete all necessary spaces
• Sign your application in space 8
SEND ALL 3 ELEMENTS IN THE SAME PACKAGE:
1. Application form
2. Nonrefundable $20 filing fee in check or money order payable to Register of Copyrights
3. Deposit material
MAIL TO:
Register of Copyrights
Library of Congress
Washington, D.C. 20559-6000

*17 U.S.C. § 506(e): Any person who knowingly makes a false representation of a material fact in the application for copyright registration provided for by section 409, or in any written statement filed in connection with the application, shall be fined not more than $2,500.

March 1995—300,000 ♻ PRINTED ON RECYCLED PAPER ☆U.S. GOVERNMENT PRINTING OFFICE: 1995—387-237/41

be protected by registration (a lengthy process that adds up in dollars if you are registering all your work)?

There is some excellent reading in the current edition of *Graphic Artists Guild Handbook of Pricing & Ethical Guidelines.* As of this writing, the 1997 eighth edition of this handbook was the most recent. This publication is updated whenever there are significant changes in pricing structure or guidelines pertinent to our industry.

Obtain a free Copyright Information Kit from the Copyright Office, Information and Publications Section, LM-455 Library of Congress, Washington, DC 20559-6000. Or call (202) 707-9100 for recorded information from the Public Information Office, available seven days a week, twenty-four hours a day. This number is also a Forms Hotline through which you can request application forms for registration (see form on page 136). In addition, specialists are available from 8:30 A.M. to 5:00 P.M. (Eastern Time) at (202) 707-3000 or (202) 707-6737 to help with your questions.

According to Circular 40, *Copyright Registration for Works of Visual Arts,* Copyright Office, Library of Congress:

Copyright is a form of protection provided by the laws of the United States to the authors of "original works of authorship," including "pictorial, graphic, and sculptural works." The owner of copyright in a work has the exclusive right to make copies, prepare derivative works, to sell or distribute copies and to display the work publicly. Anyone else wishing to use the work in these ways must have the permission of the author or someone who has derived rights through the author.

Related materials are available over the Internet. You may examine and/or download these documents through the Library of Congress campuswide information system, LC MARVEL. To access, gopher to marvel.loc.gov, port 70. Select the copyright menu. Copyright information is also available on the World Wide Web at http://lcweb.loc.gov/copyright. This address offers information created by the United States Copyright Office and offers extensive links to other copyright resources.

Maximum trademark protection must be registered by the party using that trademark (by your client, if you design a logo for him). You can get basic information about current procedures from the U.S. Patent and Trademark Office (PTO), Washington, DC 20231, by calling (703) 557-4636. There is a fee ($245 at this writing) to register a trademark, and a search must be conducted to determine whether a trademark is already in use by another party. For the Patent and Trademark Depository Library nearest you, call (703) 308-HELP. Information can be retrieved free of charge via public access terminals at these locations.

My firm uses the rubber stamp shown on page 132 on the back of every presentation board that goes out of our office. Modify the information shown here and make one for yourself immediately. The cost is about $9. It will add professionalism to your work and show your knowledge of your rights as an artist.

Give Your Client Some Education

It is my firm belief that we, as designers, illustrators and creative people of all types, are

The Walt Disney Company Corporate Travel Division

We created this logo for the Walt Disney Company's Corporate Travel Division. The old "Travel Mickey" was too tourist-looking, thus the cell phone, pullman and corporate/casual attire. Since we created a new mark using an existing icon (Mickey Mouse), the production process required us to provide comps on the concept, with our in-house illustrator drawing Mickey to the best of his abilities. Then a Disney artist redrew our concept in black and white in perfect Mickey proportions, and we scanned the black-and-white rendering into our system, cleaned it up and laid in the colors from a palette that Disney approved.

responsible for sharing copyright information with our clients. Personally review the parameters of your contract with your client. Especially review the usage rights and make certain that you both agree as to the specific usages of your work, what the client is paying for, how many times and where he can use your work, on how many printed pieces of whatever variety, etc.

Are reprints acceptable? If so, how many? Many clients, large and small, either think or feel that if they pay you for a design, illustration, etc., it is theirs to use over and over again. This is simply not true, except in the case of a logo (which is why they are priced accordingly.) Don't take for granted that a client who works for a Fortune 500 company knows better. Many people honestly do not know these

facts or they are abusive of them, brushing them aside as though they do not exist.

I generally give the client rights to use the piece as much as she likes, and I prefer to price my work accordingly. However, this is somewhat of a luxury, I know, because I have an established list of clients who are comfortable with my rates. Look at each project individually when assessing usage rights. Is it really something you can use again? Is it something you can comfortably charge a little bit more for and make the client (and don't forget you!) happy with the financial arrangement?

The last thing you want is an unhappy client who feels ripped off or a disgruntled you, resenting the client for lack of sensitivity to your creativity. I know the feeling of

being offended by clients who do not respect this situation. Do not take it personally. People who do not have creative tendencies really don't understand that your livelihood depends on the generation of your ideas into a tangible piece. Be patient, educate, negotiate and either agree or walk away from the project. An agent is a real asset to have in these situations; the agent does the dirty work, you have the fun!

Legal Issues That May Arise

Don't cringe in horror when I tell you that if you are in this business for the long term, eventually you will probably become involved in a lawsuit of some type revolving around usage rights and thus the lack of monetary reimbursement for those usage rights. This is when the attorney who created your contract will come in handy once again. Please don't let the thought of the court system infringe on your desires to become a freelancer. Most situations, even lawsuits themselves, don't ever hit the courtroom.

If you do your homework, creating a good contract with a reputable attorney's help, and educate your client about your mutually agreed-on contract, you will greatly minimize opening the door to legal problems. You must make a commitment to the value of your own work and that of the entire industry, however, when a client goes against the parameters of your agreement.

Take your education beyond your own contract when you are designing a new logo or something that you feel requires trademark

registration. Remember, you cannot register a trademark unless you are the end user. You can register the logo for your own freelance business. You cannot register the new logo that you design for Coca-Cola.

Before you enter into any task that will result in your professional or personal risk, be sure you have agreed on the procedure in your contract. An example of this might be your buying the printing or photography if you are the designer of, say, a company's capabilities brochure. If your client wants five thousand brochures and you are responsible for delivering the finished product, specifically outline the details of the press run in your contract, with the price. Same for the photography or any other charges you will be responsible for. If your client does not pay you, then you cannot afford to pay the printer or photographer, resulting in big headaches for you and your attorney.

Small-amount dollar disputes can be handled by you without an attorney through local small-claims courts. Every state has different maximum amounts of disputes (usually between $1,000 and $3,000) that they allow individuals to sue for. Call your local courts to determine what your area's maximum small claims are. If you file a small-claims suit, there will be a minimal court fee, you will personally present your case to the judge and the party you are suing will present his case. The judge will decide then and there who pays what and when, case dis-

missed. If the party you are suing does not show up for this day in court, you win automatically by default, and they are given written notice of action required by them through the courts.

In Closing

Quite honestly, I hate to end this book, especially with such a serious chapter about IRS, copyright legalities and talk of lawsuits. The very streetwise truth of the matter is that you have to know all these things to be successful at freelancing. I saved it for last not because it was the least important information in the book, but as a good way to close a rather lengthy run-on of street-smart, factual knowledge.

All the methods I have shared with you have been tried and proved true countless times. Every freelancer I interviewed for this publication was excited and enthusiastic about his or her chosen, independent career. I cannot begin to share with you the fulfillment I experience every day. I am my own boss, I do not have the worry of losing my job due to downsizing or mergers like my friends in the corporate world, I am responsible for my own destiny—me, just me. And you, just you, can be responsible for yours. Just do yourself a favor and be streetwise about it!

Permissions and Photo Credits

All images have been reproduced with the knowledge and consent of the artists concerned.

Page 11, G.A. Wintzer & Son Company "Turning Your Grease Problems into Workable Solutions" brochure © Real Art Design Group, Inc.

Page 14, Photo: Jaume Mateu.

Page 16-17, Illustrated storyboards © Adolfo Martinez-Perez.

Page 21, Zanders Paper Company "Alchemy" brochure © Real Art Design Group, Inc.

Page 28–29, Zellerbach "The Movement Continues" poster and catalog © Real Art Design Group, Inc.

Page 32, Photo: Katherine Criss.

Page 34-35, "Sheep," "Christmas Tree," "Squirrel and Birds" and "Angel" illustrations © Jan MacDougall.

Page 37, "Dancing for Tomorrow" poster © Real Art Design Group, Inc.

Page 42, Photo: Debra Matlock and Brad Grossman.

Page 44-45, Backwash logo; Planet Fez business cards; Richard Rice, Assemblage flyer graphics; 3-D logo © Planet Fez.

Page 47, Dayton Art Institute poster © Real Art Design Group, Inc.

Page 50-51, Gabbert's "Father and Son" 30-second TV commercial, Apache Mall "Back to School" newspaper ad © Sheila Berigan.

Page 54, "Art and Culture" poster © Real Art Design Group, Inc.

Page 60, Real Art Design Group, Inc. identity system © Real Art Design Group, Inc.

Page 63, Photo: Lynette Johnson.

Page 64-65, US West ISDN brochure illustrations © US West.

Page 70, "Destination Unknown" self-promotion © Real Art Design Group, Inc.

Page 74, Miami Valley Economic Development Coalition *Report to the Community* © Real Art Design Group, Inc.

Page 79, Photo: Rick Chard.

Page 80-81, All illustrations © Franklin Hammond.

Page 84, SynNETry identity system © Real Art Design Group, Inc.

Page 88, Dayton Opera poster © Real Art Design Group, Inc.

Page 91, Photo: Scott Hull.

Page 92-93, William Tell Situation illustration © John Ceballos; "Cow Planning His Trip Over the Moon" © South-Western Bell.

Page 98-99, Itzago brochure, invitation and label; direct-mail fashion catalogs; announcements; Khadra International Folk Ballet poster, mailer, newspaper ad and logos © Linda Souders.

Page 104, Proposed logo for MCSI © Real Art Design Group, Inc.

Page 105, MCSI corporate identity materials © Real Art Design Group, Inc.

Page 109, "Cat in Room" illustration, "Hot Dog Man" illustration, Timex Indiglo Bug calendar © Geoffrey Smith.

Page 111, Universal Studios' CityWalk ads © Real Art Design Group, Inc.

Page 117, Lexis-Nexis software library binder, mailing envelope and advertising brochures © Real Art Design Group, Inc.

Page 122-123, "Hands/Bridge," "Flying Sanguines," "The Girl Ascending from the Well," "The Silver Spoon" illustrations © Curtis Parker.

Page 128, "Suddenly" Cub Foods ads © Real Art Design Group, Inc.

Page 132, Real Art Design Group, Inc. rubber stamp © Real Art Design Group, Inc.

Page 138, Walt Disney Company Corporate Travel Division letterhead and note card © Real Art Design Group, Inc.

Directory of
Contributors

Sheila Berigan (partners occasionally with freelance
writer Shelley Kingrey)
1846 Sargeant Ave.
St. Paul, MN 55105
(612) 698-3519
Freelance designer with great presentation skills and
savvy.

John Ceballos
1047 Broadmoor Dr.
Napa, CA 94558
(707) 226-1026
Former art director for Hallmark and Gibson
Greeting Cards; freelance illustrator for nine years
doing editorial/humorist-type work.

Josef Gast
527 Wellington
Seattle, WA 98122
(206) 720-1033
Freelance illustrator who struggled for his first five
years being independent; is now getting great work
with an agent.

Franklin Hammond
5 Rumsey Rd.
Toronto, Ontario, Canada M4G 1N5
(416) 696-6164
Freelance illustrator whose work has recently come
on strong. Doing illustrations for Apple's web
site product due out in fall 1997. Featured in
Step-by-Step magazine.

Mark Levy
Attorney-at-Law
Thompson, Hine & Flory
2000 Courthouse Plaza NE
P.O. Box 8801
Dayton, OH 45401-8801
(937) 443-6949
Specializes in advertising law.

Jan MacDougall
260 E. 78th St., Apt. 8
New York, NY 10021-2037
(212) 744-1472
Was an art director for an ad agency for many years.
Now does freelance design and illustration.

Adolfo Martinez-Perez
2167 Beechwood Terrace, #9
Hollywood, CA 90068
(213) 467-8732
Storyboard freelance illustrator for movie sets.

Debra Matlock/Brad Grosman
Planet Fez Productions
P.O. Box 291849
Los Angeles, CA 90029
(213) 665-3008
Freelance studio partners—designers.

Curtis Parker
1946 E. Palamino Dr.
Tempe, AZ 85284
(602) 820-6015
Owned a design shop, then directed his focus to
illustration after selling his share of the studio.
Freelancer for more than ten years.

Geoffrey Smith
217 Greendale Dr.
Dayton, OH 45429
(937) 294-2288
Freelance illustrator with a very simple business
approach.

Linda Souders
555 Buena Vista West, #702
San Francisco, CA 94117
(415) 252-5820
Freelance designer/art director with incredible
insight; specializes in direct-mail projects. Has
been freelancing for ten years.

Index

A

Accountant. *See* Tax accountant
Advertising agency, defined, 57
Agent
 for Franklin Hammond, 78-79
 recognizing need for, 69-72
 selecting, 63, 121
 as time-saver, 103
AIGA
 credit cards through, 36
 joining, 40
American Advertising Federation,
 credit cards through, 36
American Showcase, 71
Assignments, learning to decline, 90, 94
Assistant, pros and cons of having, 94
Attorney, for contract, 132-133

B

Banking. *See* Credit, establishing;
 Financing, creative
Berigan, Sheila, 48-51
Billing, 121, 127, 129
Body language, 82
Brochure, for self-promotion, 43,
 62-63, 66-67
Budget
 agreement on, 94
 establishing, for equipment, 30-31
 for identity system, 56-57
 See also Cost
Burn-out, 15
Business, finding. *See* Client, finding
Business cards
 proper time to exchange, 61-62
 See also Identity system

C

Calendars, 9-10, 14-15
 See also Day planner
Ceballos, John, 91-93
Chamber of commerce, joining, 40
Checkbook register, 103-104
Cleaning, importance of, 10
Client
 finding, 39-41
 inexperienced, 97
 learning to read, 59-61
 ongoing, raising rates on, 121
 and politics, 87-88
 questions for, 104, 106
 saying no to, 90, 94, 97
 styles of approaching, 15-16
 thanking, 96
 using positive approach with, 116,
 118
Client, educating, 86-87, 94-95, 116

about copyright, 137-138
 as time-saver, 103
Client, potential
 contacting directly, 72
 following through with, 43
Collaboration, on self-promotion
 piece, 66
Collections, 129
Colleges and universities, using
 student labs at, 38
Commitment, 89-90
Communication
 with clients, 79
 effective tools for, 82-85
 skills, 77, 82
 tips for improving, 85
 See also Body language
Competitions, as vehicle for self-
 promotion, 66-67
Computer
 designers' use of, 24
 software, seminars on, 77
 See also Equipment
Concept, educating client about,
 86-87
Consistency, in operations, 125
Contract
 with agents, 71-72
 payment terms in, 127
 using attorney for, 132-133
Copyright law, 133-135, 137
Cost. *See* Expenses; Rates
CPA. *See* Tax accountant
Creative freedom, negotiating for, 120
Creative industry, differences within,
 57-59
Credit
 establishing, 124-125
 using, to buy equipment, 31, 36, 38
Criticism, handling, 20

D

Day planner, 9
 to set monthly goals, 19
Deadlines, meeting, 15
Deductions. *See* Tax deductions
Delegating, 110
Designers, agents for, 71
Design firm, defined, 57
Design skills, streetwise, 73-75
Dress, appropriate, 18

E

Enunciation, importance of, 82-83
Equipment
 choosing and paying for, 30-31,
 36, 38

mail-order, 31
 necessary, 33, 36
 used, 33
Ergonomics, in studio, 26
Expenses
 paring down, for self-promotion
 piece, 62, 66
 tracking, 131, 133
Experience, staff, before becoming
 freelancer, 73, 91, 93, 108
Expertise
 expected from freelancer, 76
 sharing, with client, 91, 97
Eye contact, 82

F

Financing, creative, 31, 36
Flexibility, importance of, 86-87, 91, 97
Follow-through
 during and after project, 97, 99
 ideas for, 53
 importance of, 43, 47, 49, 52
Forms, 102-104
 for credit references, 127
Freelancer
 advice for, 108
 being the best, 100
 defined, 58-59
 expertise expected from, 76
 and vacations, 108, 110, 112
Freelancing
 determining aptitude for, 7-8
 entry into, 78
 ground rules for, 90
 making commitment to, 89-90
 pros and cons of, 12, 15
 reasons for, 14, 16
 rewards of, 23
 vs. ad agency, 32

G

Gast, Josef, 63-65
Goals
 setting monthly, 19-20
 writing down, 89
Graphic Artists Guild Directory of
 Illustration, 71
Graphic Artists Guild Handbook of
 Pricing & Ethical Guidelines,
 94, 137
Grossman, Brad, 42-43

H

Hammond, Franklin, 78-81
Home, working from
 ground rules for, 90
 and setting limits, 26-27
Hull, Scott, 78-79

I

Identity system, 56-57
 advice for creating, 63
 elements of, 58
Illustration skills, streetwise, 73-75
Illustrators, agents for, 70-71
Image
 personal, 18
 through identity system, 56-57
Internal Revenue Service (IRS), 130-133
Intuition
 as decision-making tool, 99
 importance of, 96, 100
Invoicing. *See* Billing

J

Jargon, 83
Job jackets, 9-10

L

Lawsuits, possible, 138-140
Levy, Mark, 134-135
Lighting, for studio, 26
Line of credit, establishing, 121, 125-127

M

MacDougall, Jan, 32-33
Macintosh PowerBook, 68
Magazines, trade, 76
Management, of self, 10-13, 18
Marketing
 as studio vs. as individual, 42
 ways of, 43, 49
 with web site, 53-55
Marketing consultant, defined, 58
Martinez-Perez, Adolfo, 14-17
Matlock, Debra, 42-43
Mileage, tracking, 133
Motivation, for freelancing, 18
Myers-Briggs Type Indicator, 83-85

N

National Seminars, 47
Negotiating
 techniques, 120
 tips for, 118
 winning at, 113-114
Networking, 39-40, 42, 48
New job/log forms, 102

O

Objective, organizing portfolio by, 68
Office. *See* Studio
Organization, ways to achieve, 14-15
Organizational skills, 8-10
 tools for, 9
Overhead, 119

P

Paperwork, 102-104
Parker, Curtis, 120-123
Persistence, vs. annoyance, 59

Personality assessments, 83-85
Phone calls, setting time for, 110
Planet Fez Productions, 42-45
Politics, client, 87-88
Portfolio
 cleanliness of, 69
 do's and don'ts of, 71
 paring down, 49
 presenting, 39-40, 68-69
 soliciting feedback about, 59-60
 type of, 67-68
Pricing, Estimating and Budgeting, 124
Pro bono work, 40-43, 47, 48, 54
 scheduling, 110
Procrastination, 46, 49
 getting caught at, 106, 110
 pros and cons of, 108
 tips for avoiding, 52
Professional environment, importance of, 25-26
Professional organizations, 40
 volunteering for, 61
Projects, juggling multiple, 14
Public relations firm, defined, 58
Public speaking, 62
Purchase orders, 102-103

Q

Quality
 striving for best, 95-96
 vs. quantity, 13
Questions
 for client, 104, 106
 to define negotiating tactics, 113-114

R

Rates
 establishing, 118-121, 124
 raising, 124
Register symbol, 135
Representative. *See* Agent
Responsibility, 9

S

Sales techniques, 61-62
Scheduling, 107-108
Self-confidence
 building, 46-47
 developing, 18-22
Self-discipline, 10-13, 15
 time management and, 107
Self-esteem, maintaining, 15
Self-promotion
 brochure for, 62-63, 66-67
 effective, 66-67
 long-term, 59-61
Selling, importance of, 61-62
Seminars, 47
 software, 77
Service bureau request forms, 103
Skill Paths Seminars, 47
Skills

communication, 77, 82
 design and illustration, 73-77
 necessary, for freelancer, 79
Skills, up-to-date, 75-77
 as time-saver, 103
Smith, Geoffrey, 107-109
Souders, Linda, 97-99
Specializing, 41, 43, 46, 48-49
Strengths and weaknesses, knowing, 20-21
Studio
 expanding out of home, 27
 lighting, 26
 naming, 42
 setting up, 32-33
 vs. individual, marketing as, 42
 See also Workspace
Studio, home-based, 24-27
 ground rules for, 90
Success, handling, 22

T

Tax accountant, 38, 130-132
Tax deductions, 131-132
Teaching, to keep skills current, 77
Telephone skills, importance of, 46-47
Television, as niche, 48-49
Third-party services, for buying equipment, 31
Time management, 13
 and paperwork, 102-104
 tips for, 110
 and vacations, 110, 112
 and work process, 101-102
 See also Procrastination
Time sheets, 102
Tobias, Greg, 88
Trade magazines, 76
Trademark symbol, 134-135
Trade shows, 76-77
Training, 78

V

Vacations, importance of, 108, 110, 112
Value, determining, of project, 119, 124
Volunteer work. *See* Pro bono work

W

Web site
 Apple's, 79
 for marketing, 53-55
Win-win philosophy, 114-115, 117
Work process, 101
Workspace
 cleaning and organizing, 8-10
 setting up ideal, 30
 time management and, 103
World Wide Web, 53-55

144

THE STREETWISE GUIDE TO FREELANCE DESIGN AND ILLUSTRATION